Steven O'Brien
Twenty Four Preludes, Op. 2

Copyright © 2012 Steven O'Brien

This work is licensed under the Creative Commons Attribution 3.0 Unported License.
To view a copy of this license, visit http://creativecommons.org/licenses/by/3.0/ or send a letter to Creative Commons, 444 Castro Street, Suite 900, Mountain View, California, 94041, USA.

IBSN: 978-1-291-00409-0

Revision 1

Contents

Interpretation notes	1
Further Information	2
Translations	3

Twenty Four Preludes, Op. 2

No. 1 in C major, Op. 2a – Lento	4
No. 2 in A minor, Op. 2b - Allegro agitato	5
No. 3 in G major, Op. 2c - Presto	7
No. 4 in E minor, Op. 2d - Presto agitato	9
No. 5 in D major, Op. 2e - Adagio morendo	11
No. 6 in B minor, Op. 2f - Allegro moderato e misterioso	12
No. 7 in A major, Op. 2g - Presto	16
No. 8 in F-sharp minor, Op. 2h - Allegro agitato	19
No. 9 in E major, Op. 2i - Vivace con brio	21
No. 10 in C-sharp minor, Op. 2j - Adagio con dolore	24
No. 11 in B major, Op. 2k - Moderato	27
No. 12 in G-sharp minor, Op. 2l - Largo grave e sostenuto	28
No. 13 in F-sharp major, Op. 2m - Allegro giocoso	29
No. 14 in E-flat minor, Op. 2n - Presto agitato e con fuoco	31
No. 15 in D-flat major, Op. 2o - Lento assai	35
No. 16 in B-flat minor, Op. 2p - Larghetto agitato	38
No. 17 in A-flat major, Op. 2q - Allegretto	39
No. 18 in F minor, Op. 2r - Allegro pathetique	43
No. 19 in E-flat major, Op. 2s - Adagio sostenuto	45
No. 20 in C minor, Op. 2t - Andante grave	48
No. 21 in B-flat major, Op. 2u - Largo appassionato e cantabile	53
No. 22 in C major, Op. 2v - Allegro con fuoco	57
No. 23 in F major, Op. 2w - Lento sostenuto	60
No. 24 in D minor, Op. 2x - Prestissimo agitato	61

Interpretation Notes

In order to avoid any confusion in the interpretation and performance of these preludes, a brief explanation on how certain aspects of this score should be interpreted has been provided below.

A short fermata (∧) should be interpreted as a very short pause or hesitation, almost as if the music slows down slightly for an instant in anticipation of the note or phrase that follows it. The performer should not hold notes or rests with a short fermata for more than half of a beat.

A standard fermata (⌒) should be interpreted as a short pause, adding no more than one beat to the value of the note or rest in question.

A long fermata (⊓), similar to a standard fermata, should be interpreted as a long pause, adding between one and three beats to the value of the note or rest in question.

A tenuto mark (-) indicates that the note should be held slightly longer than its written value, almost giving the impression that it is extending into the following note.

An accent mark (>) indicates that the note should be emphasized moreso than the notes that surround it.

A staccato mark (.) indicates that the note should be played with roughly half of its written value.

A staccatissimo mark (▾) indicates that the note should be played with an emphasized attack, and a very quick release, almost in the manner of pizzicato on a string instrument.

Brackets around a note head ((●)) indicate that the note should be played with much less emphasis than the notes that surround it.

If the duration of the performance is a sensitive issue, the performer can treat any repeat signs liberally, and choose to ignore any that would cause the performance to continue for too long. However, in order to maintain a sense of balance throughout the performance, the performer should try to retain as many of these repeats as possible.

The metronome markings throughout these preludes should only be treated as recommendations. Ideally, the performer should aim to play within 10BPM of the recommended marking.

If these preludes are being performed on a piano with an extended lower bass range (such as the Bösendorfer 290), Preludes No. 20 and No. 24 have optional notes that utilise this extended range. Instructions have been provided on how to use these notes where appropriate.

Further Information

If you have any questions regarding these preludes, or any other works by Steven O'Brien, feel free to send an email to steven@steven-obrien.net. Reference recordings and further information, including a digital version of this score for reprinting can be found at http://www.steven-obrien.net/. Steven O'Brien can also be found on twitter @SELOBrien.

Translations

Lentissimo	Very slowly
Lento	Slowly
Largo	Slowly
Larghetto	Quite slowly
Adagio	Quite slowly
Andante	Moderately slowly
Moderato	Moderately fast
Allegretto	Moderately fast
Allegro	Fast
Vivace	Quite fast and lively
Presto	Very fast
Prestissimo	As fast as possible
Sempre	Always...
Con	With...
Molto/Assai	Very...
Poco	A little...
Ad libitum/Rubato	With free tempo
Agitato	With agitation
Doloroso/Dolore	With pain
Morendo/Mesto	With grief
Brio	With vigor
Energico	With energy
Animato	With animation
Forzando	With force
Grave	With sadness
Maestoso	With majesty
Mesto	With grief
Giocoso	With joy
Fuoco	With fire
Staccatissimo	With very pointed staccato
Resoluto	With a sense of resolution
Leggieramente	Delicately
Misterioso	Mysteriously
Marcato	Markedly (Accented)
Sostenuto	Sustained
Pathetique	Pathetically
Appassionato	Passionately
Cantabile	Song-like

Prelude No. 1
in C major, Op. 2a

Steven O'Brien

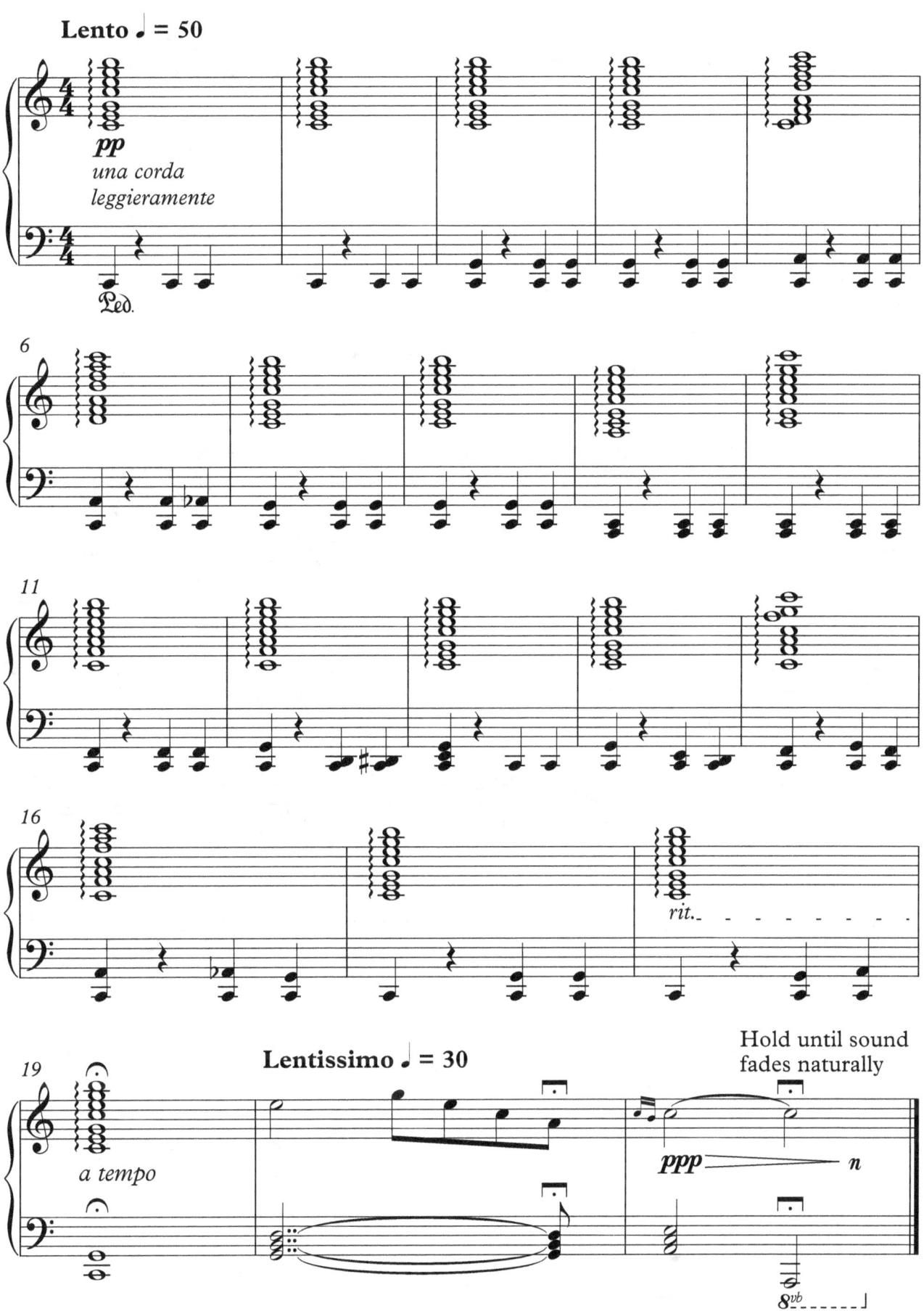

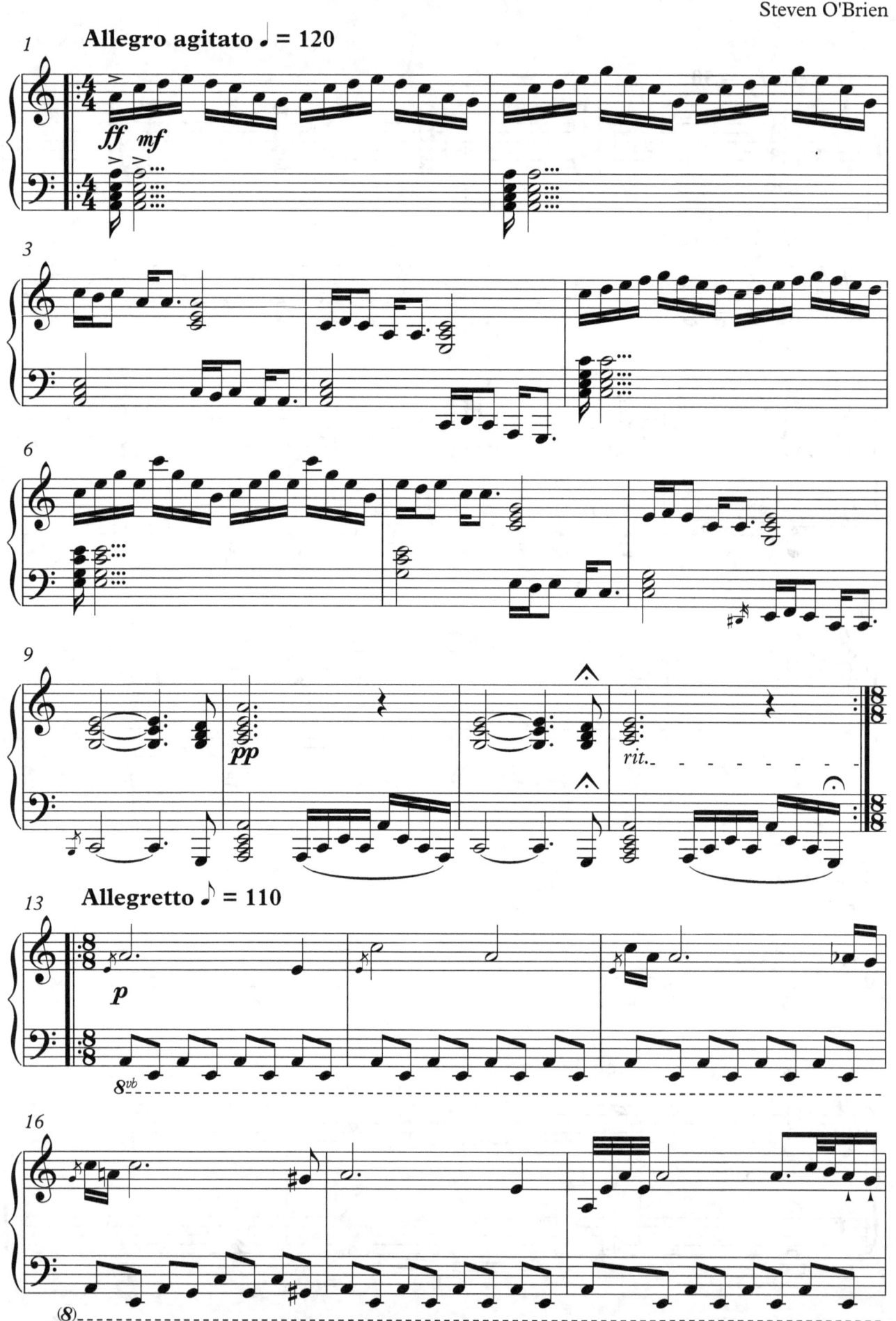

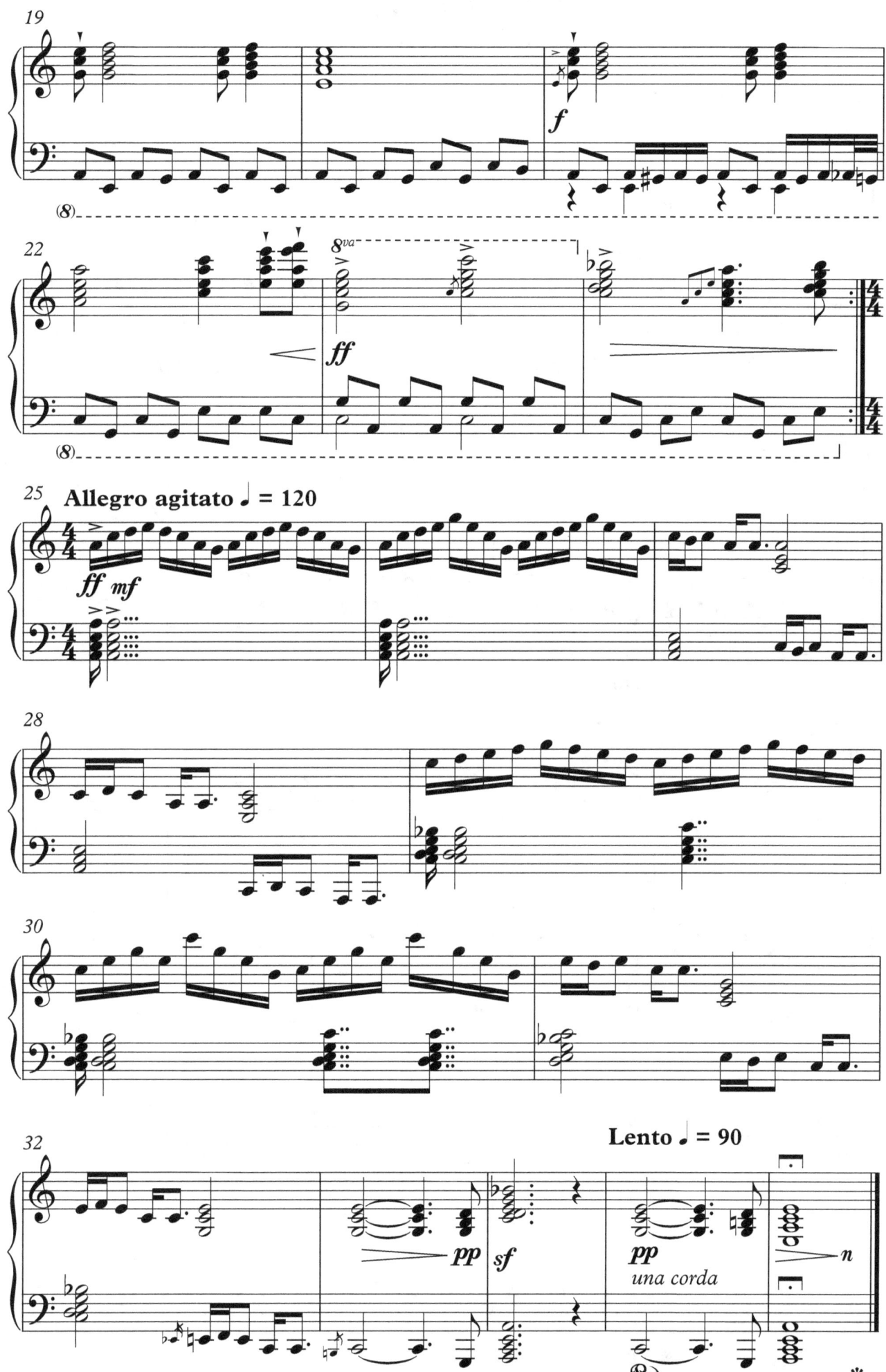

Prelude No. 3
in G major, Op. 2c

Steven O'Brien

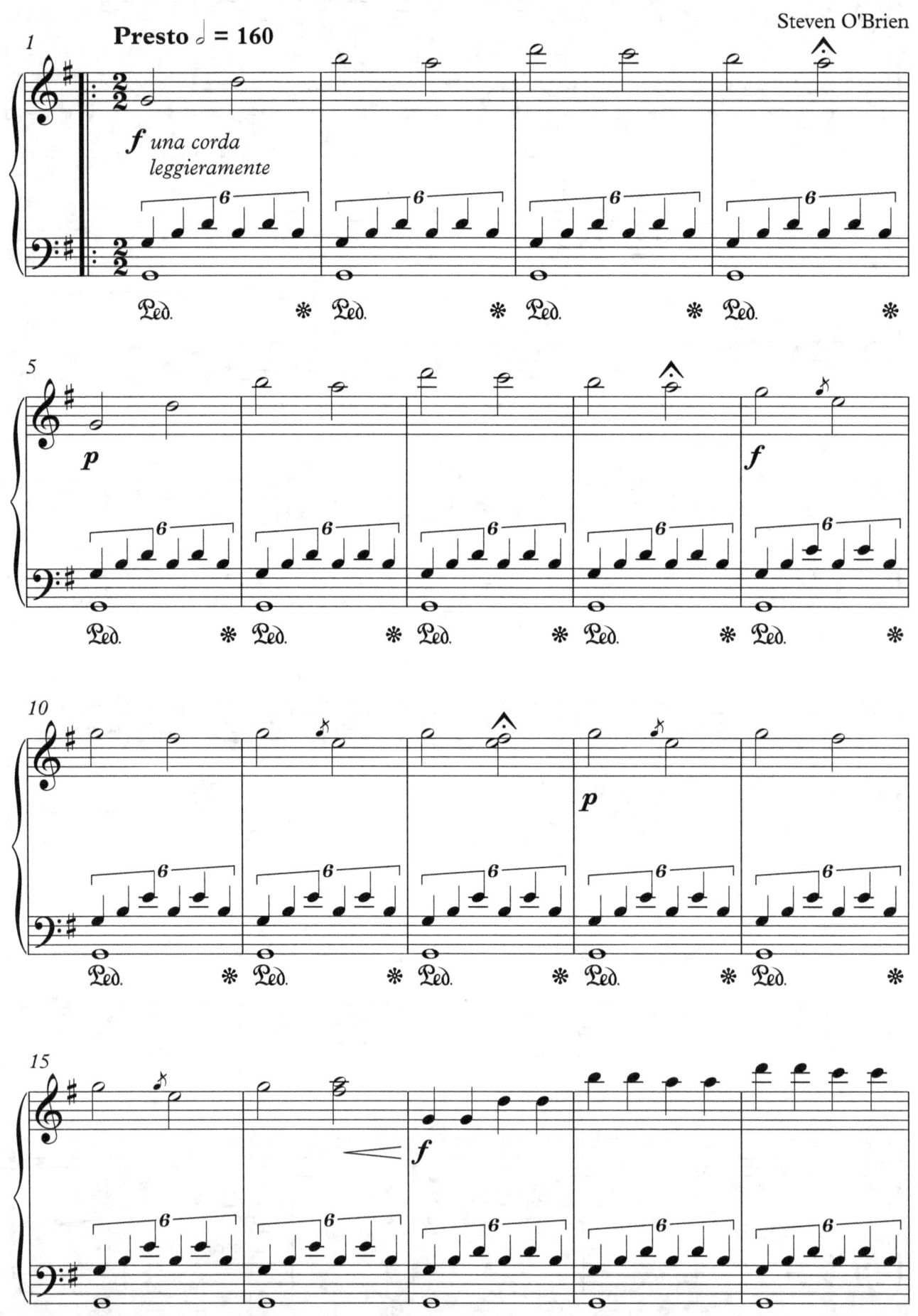

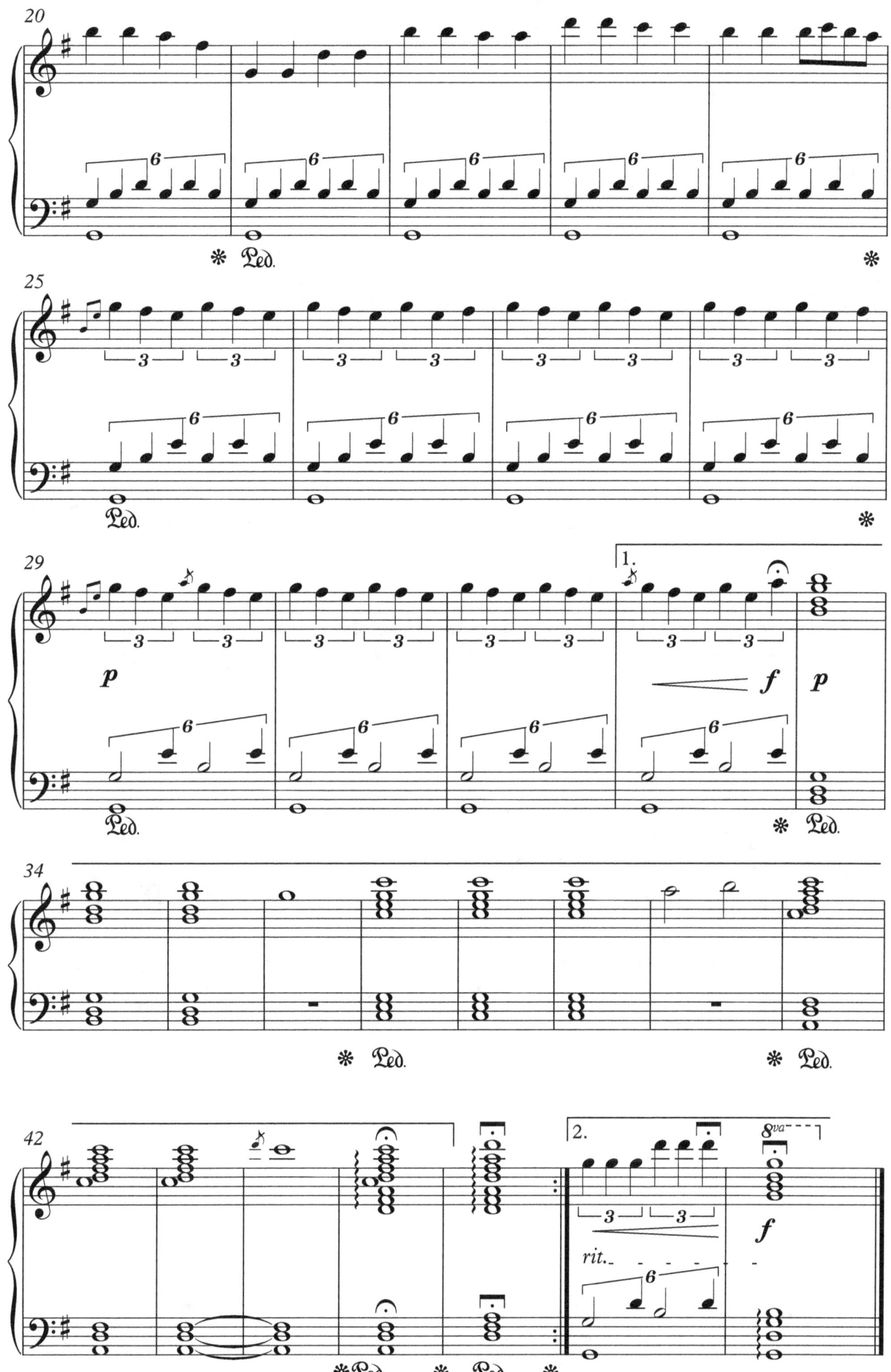

Prelude No. 4
in E minor, Op. 2d

Steven O'Brien

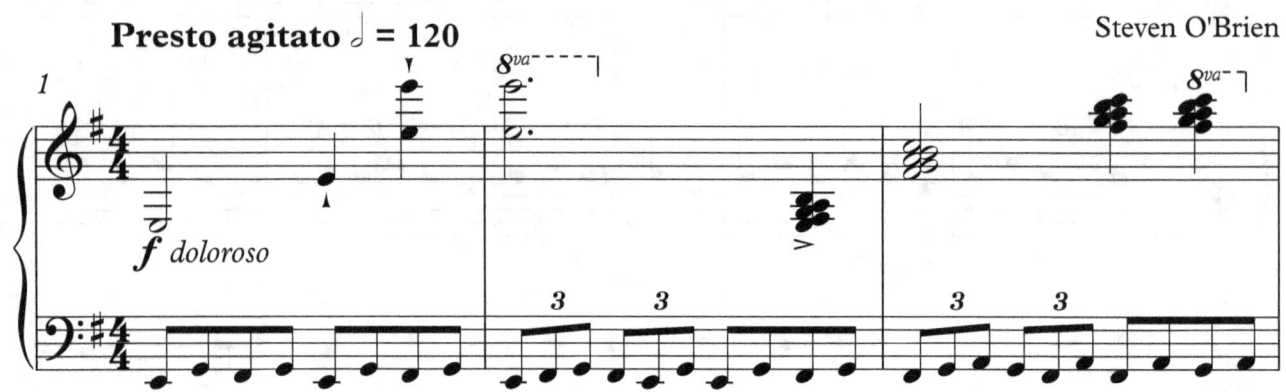
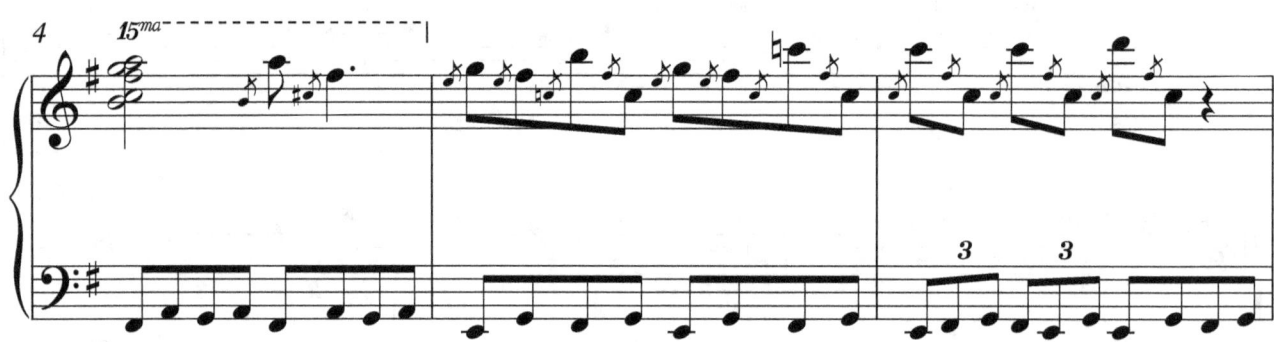
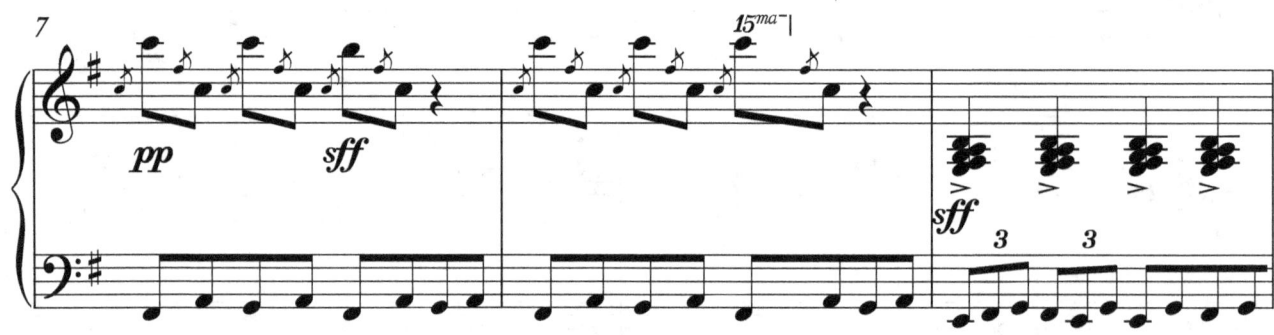
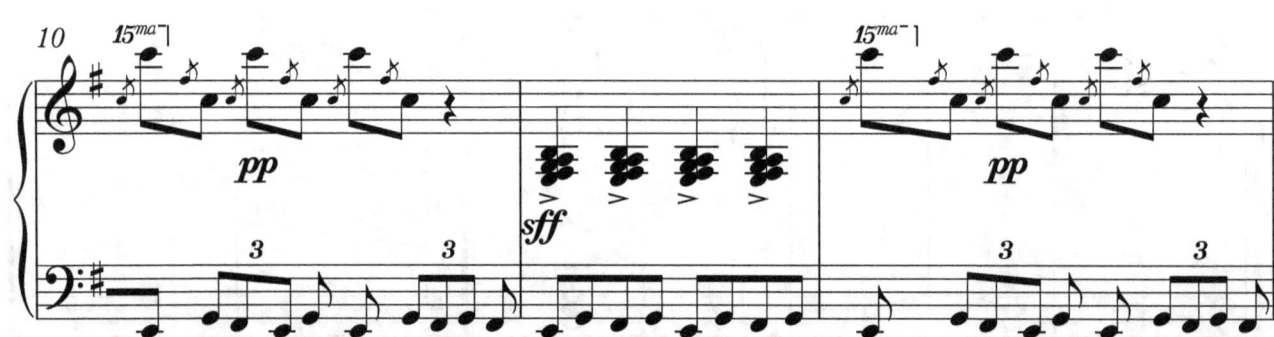

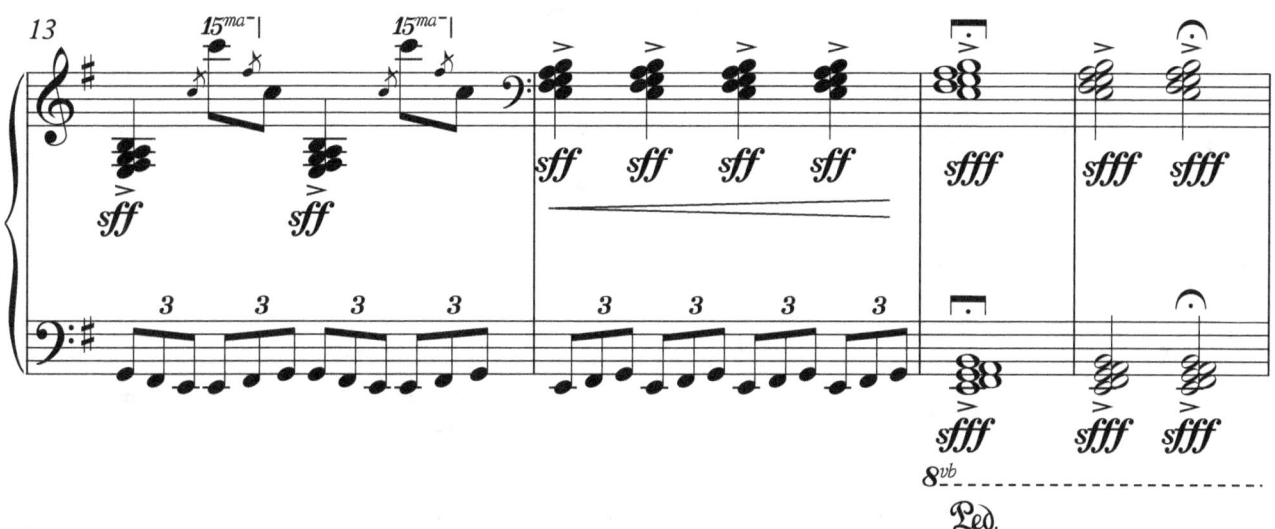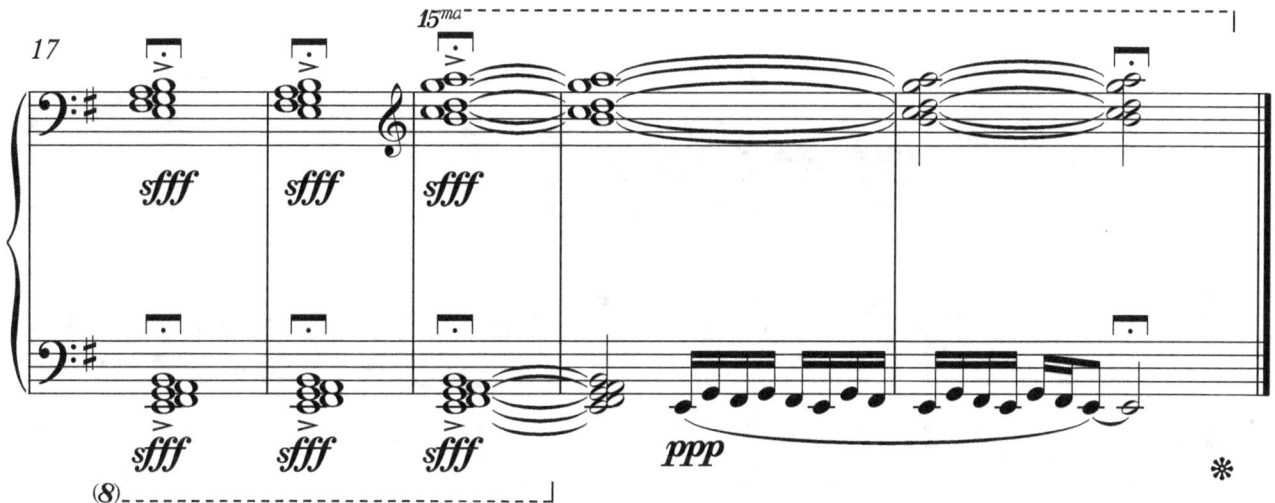

Prelude No. 5
in D major, Op. 2e

Steven O'Brien

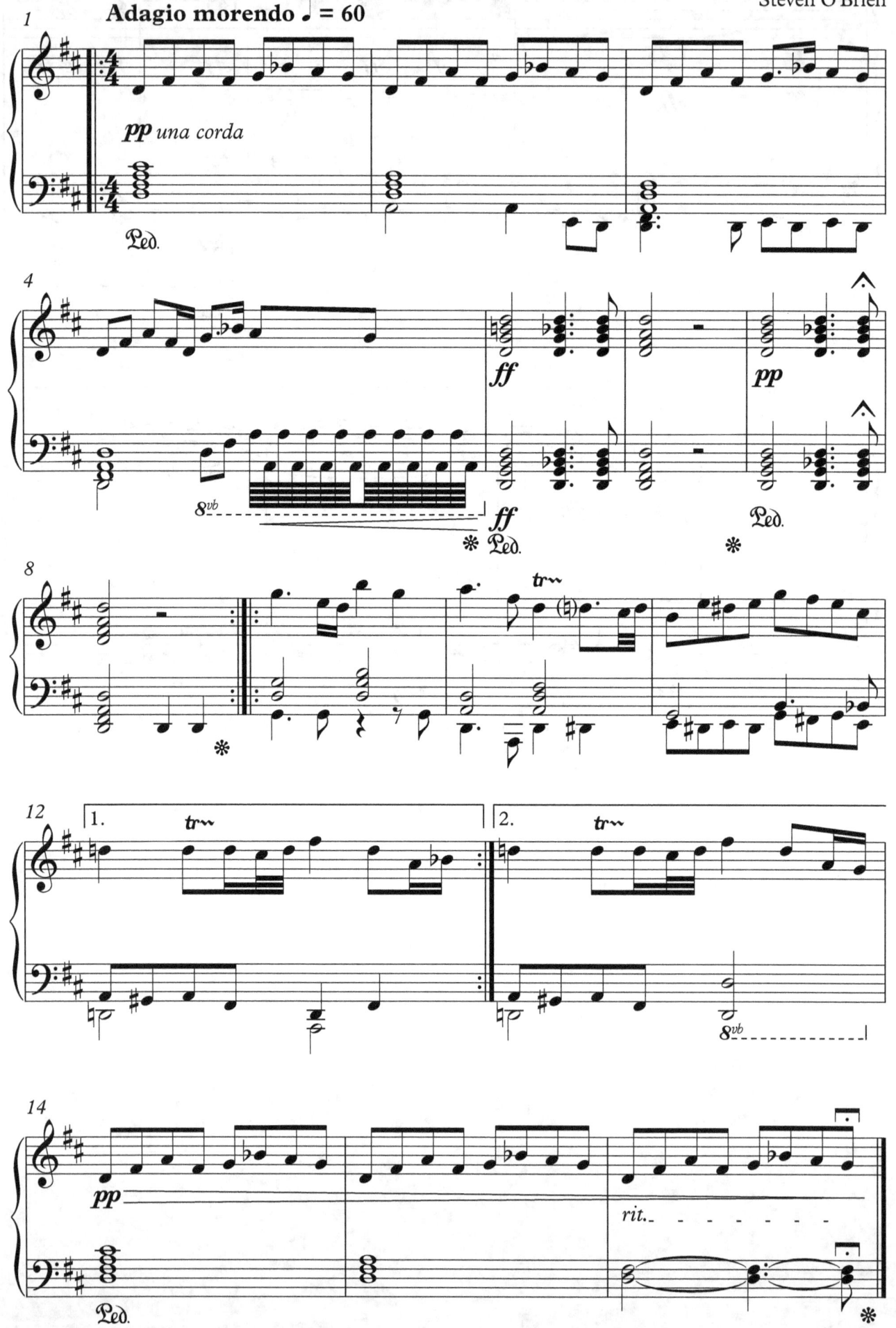

Prelude No. 6
in B minor, Op. 2f

Steven O'Brien

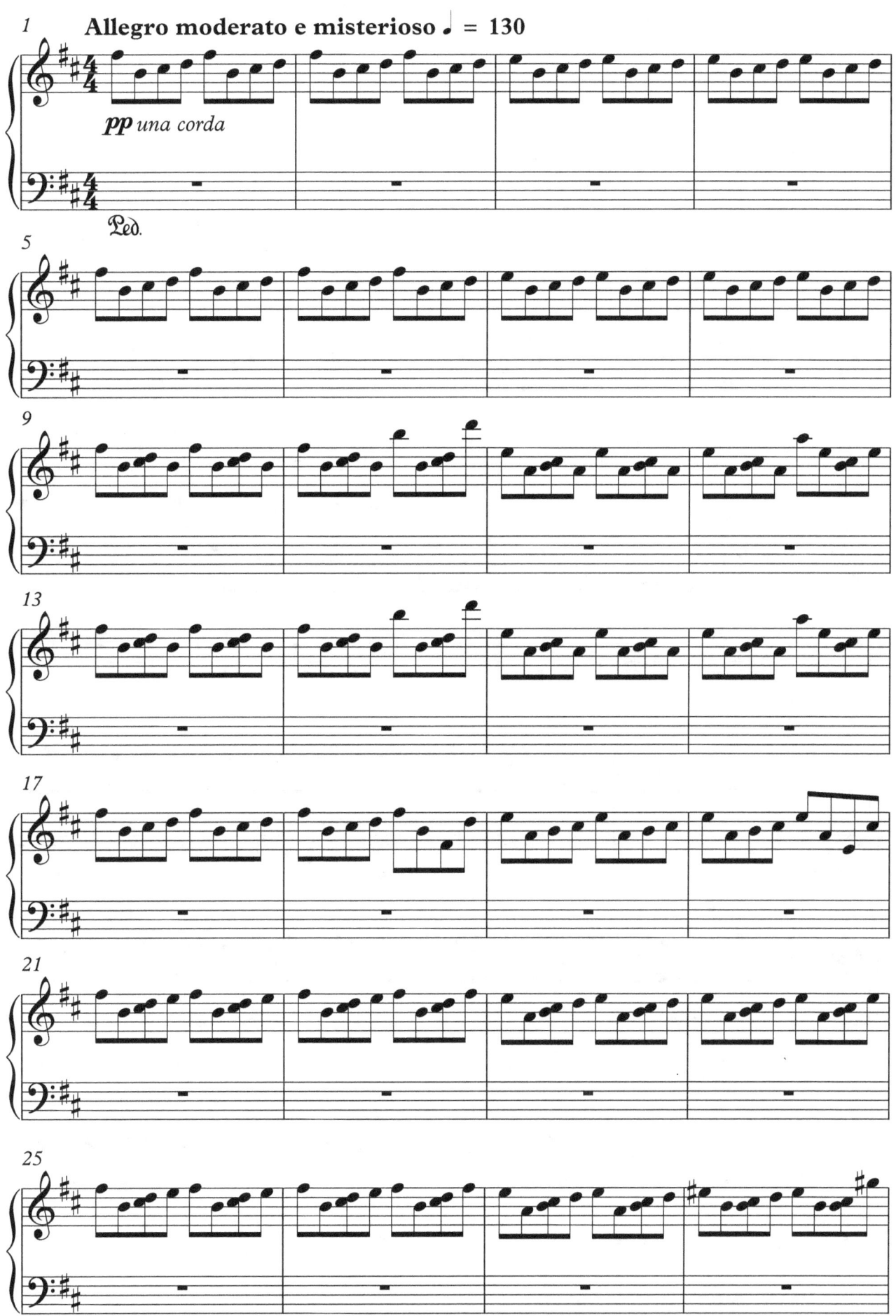

Prelude No. 7
in A major, Op. 2g

Steven O'Brien

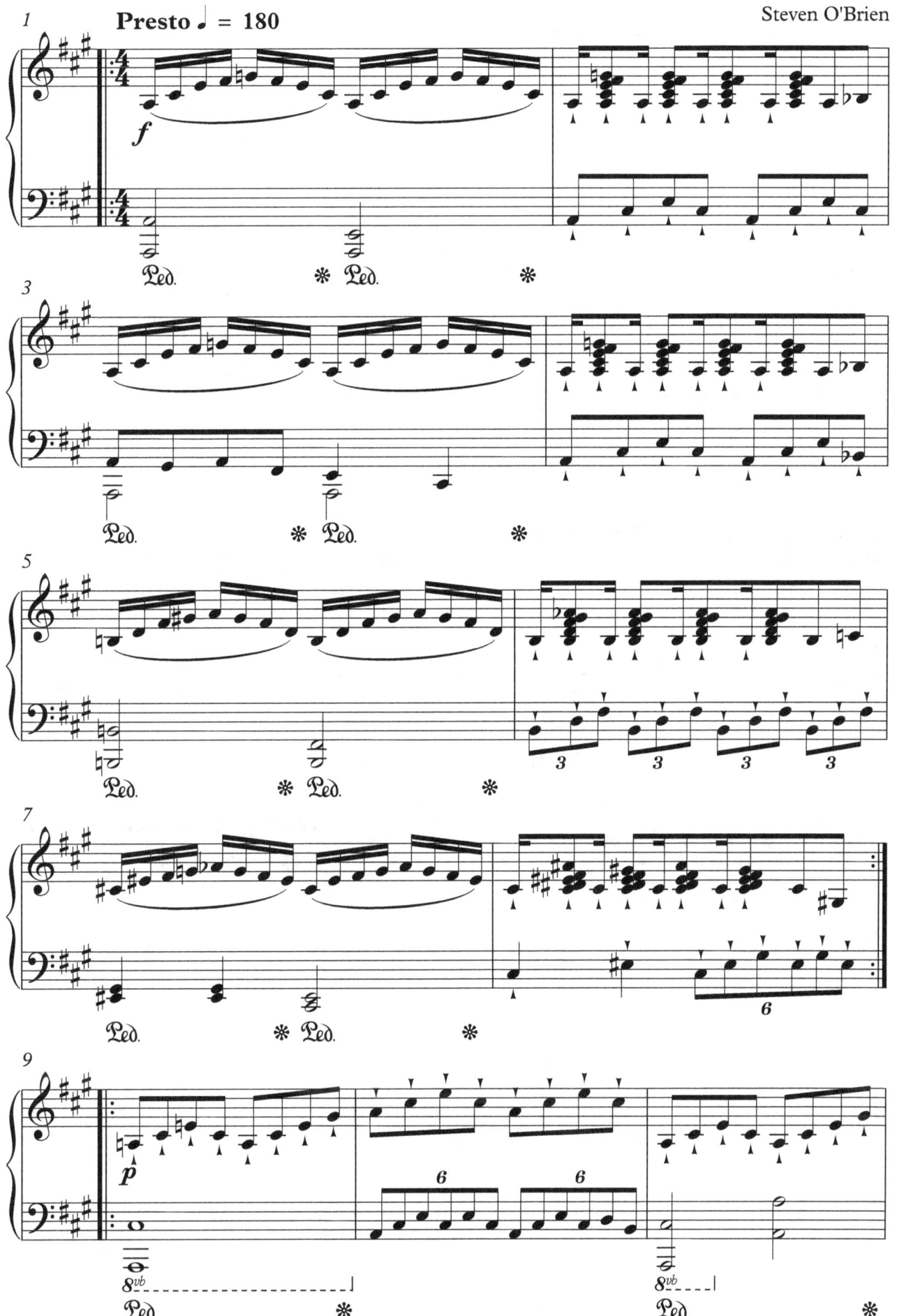

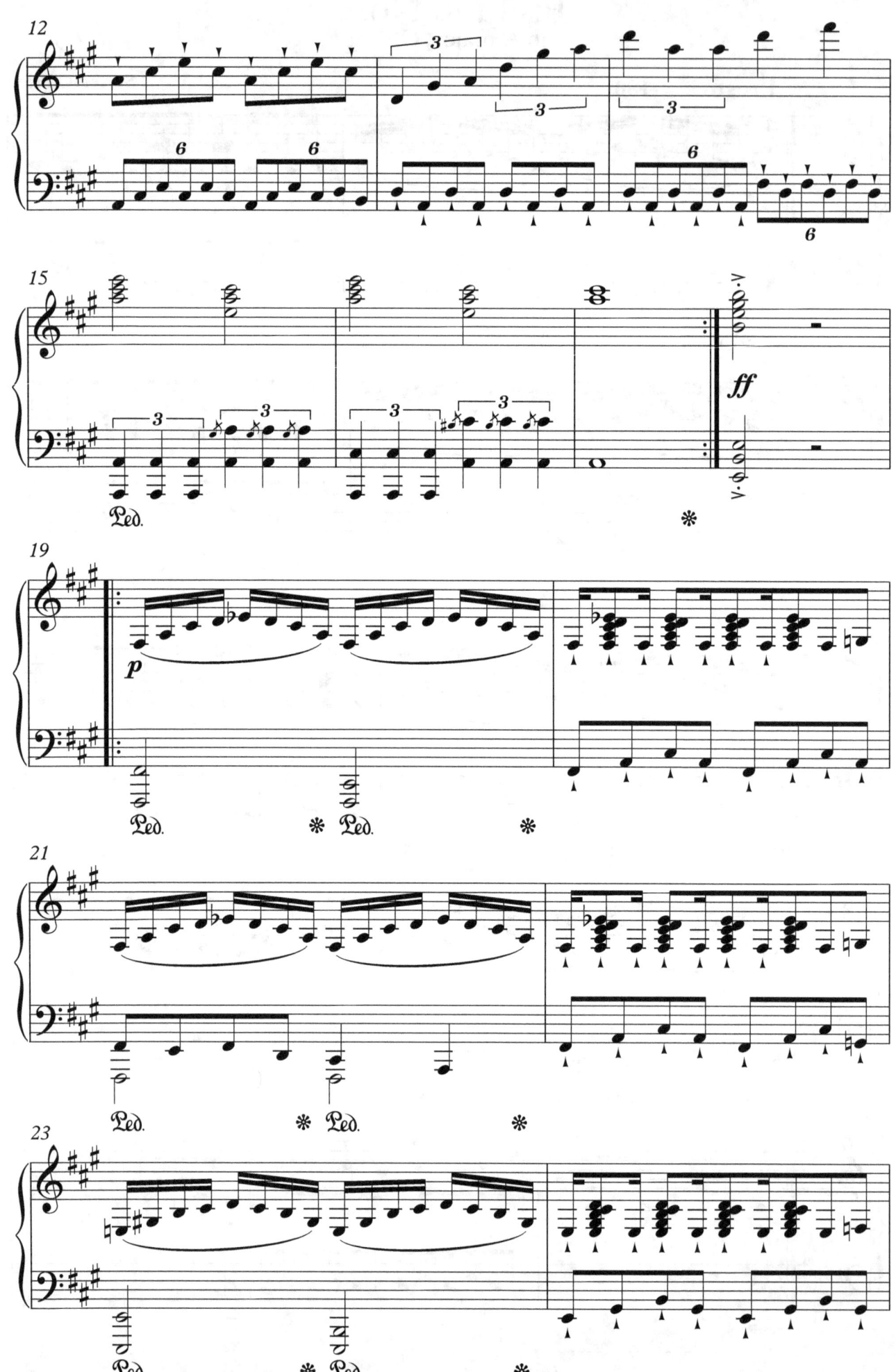

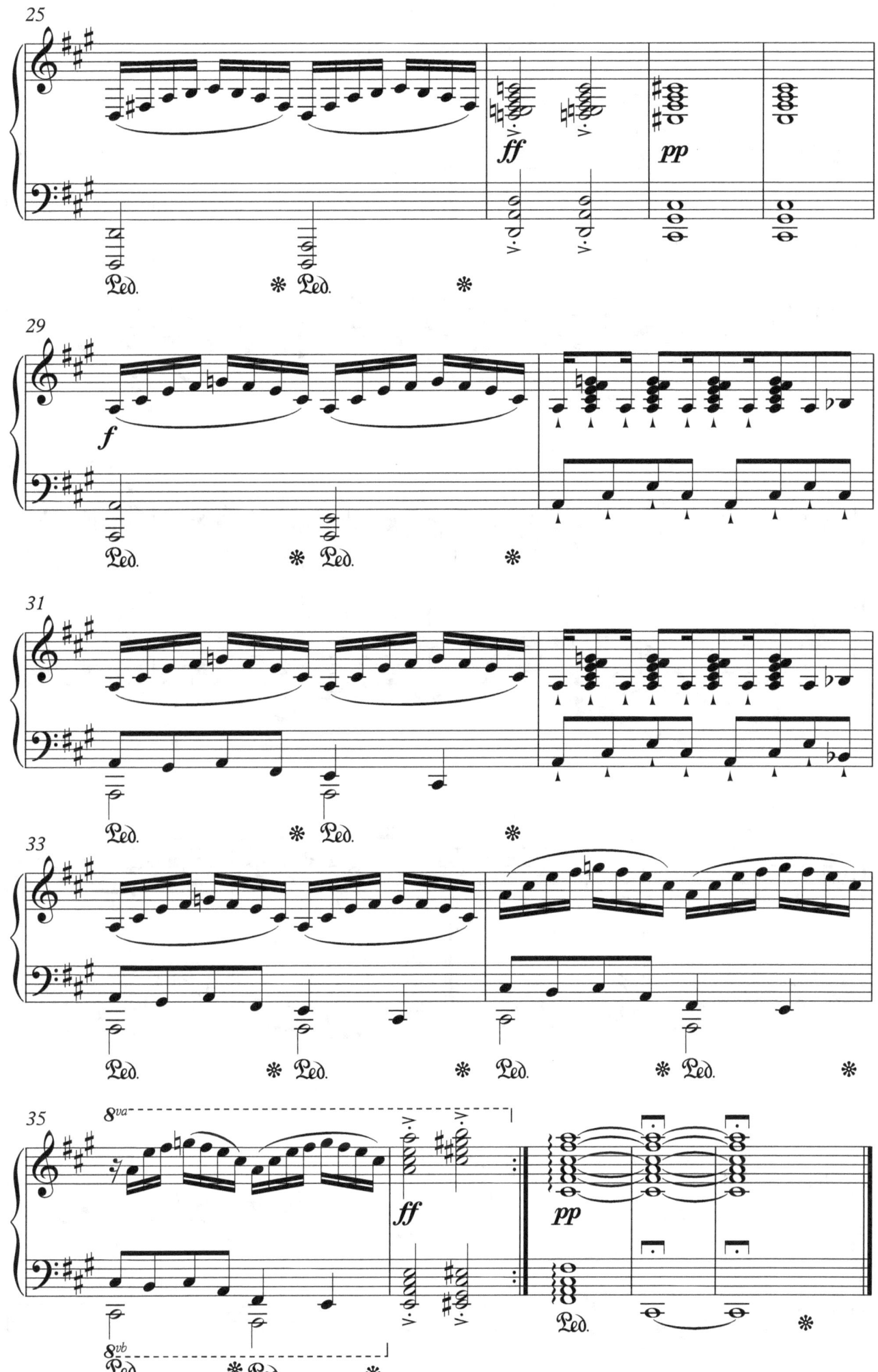

Prelude No. 8
in F-sharp minor, Op. 2h

Steven O'Brien

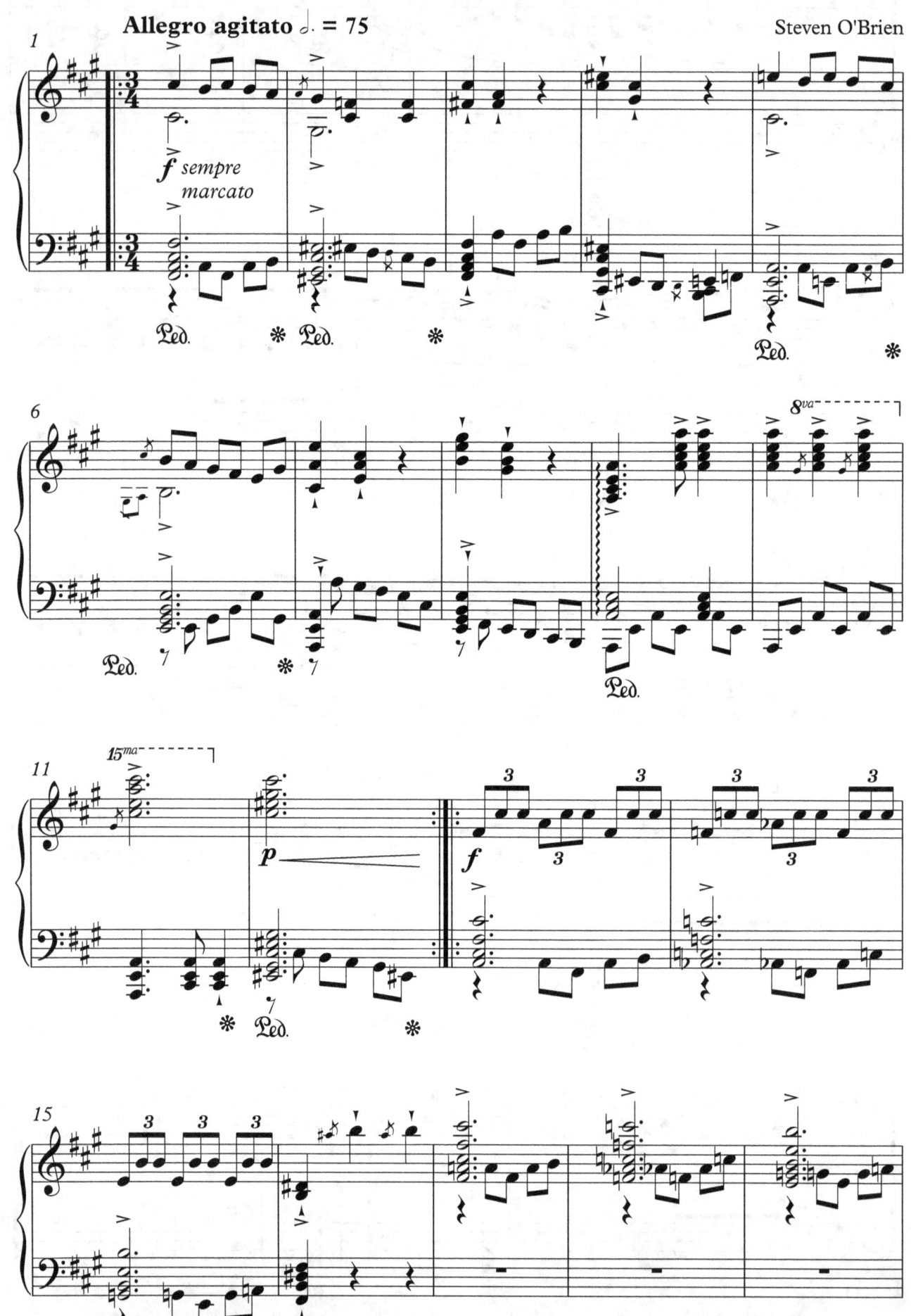

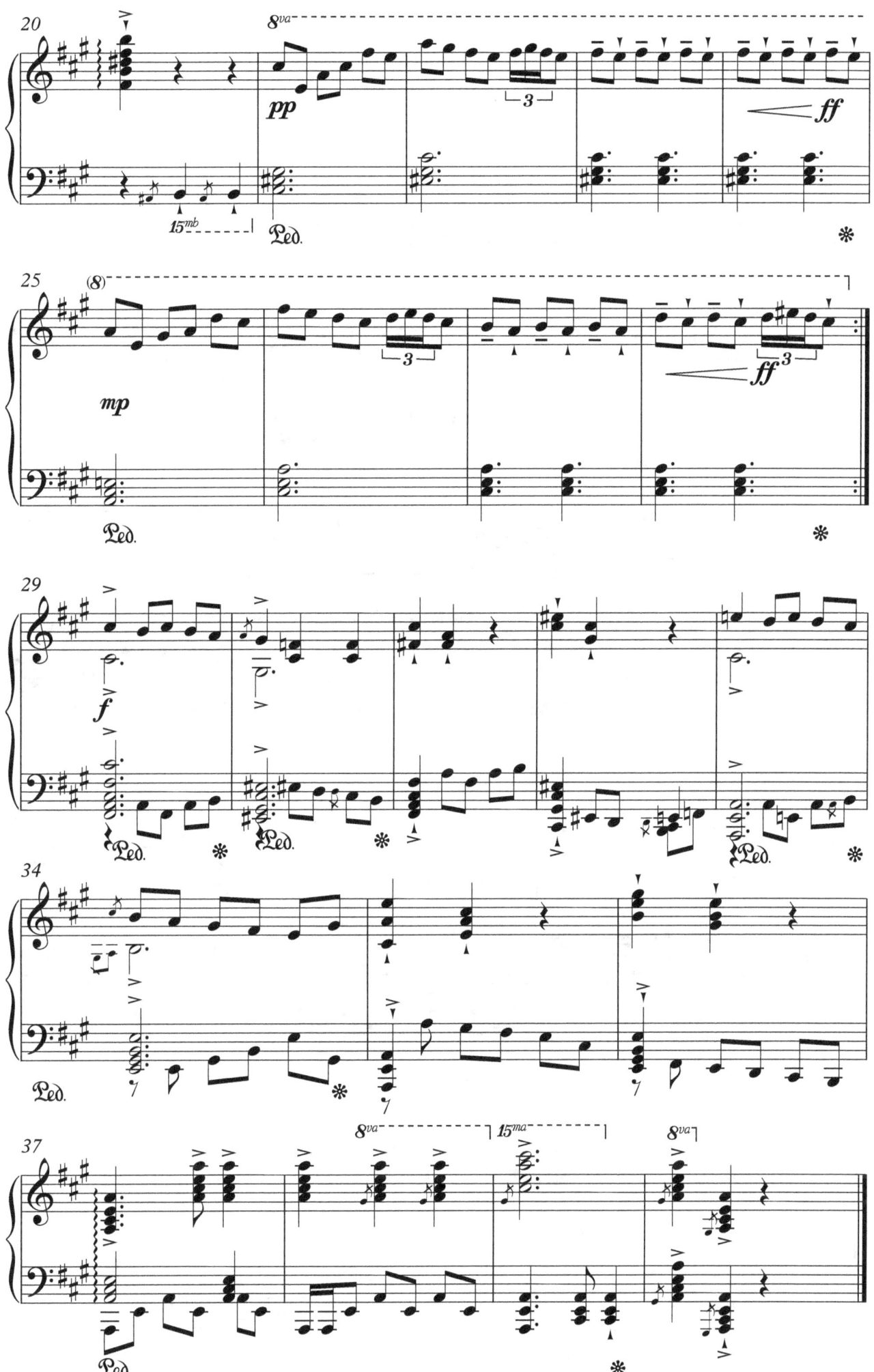

Prelude No. 9
in E major, Op. 2i

Steven O'Brien

Vivace con brio ♩. = 105

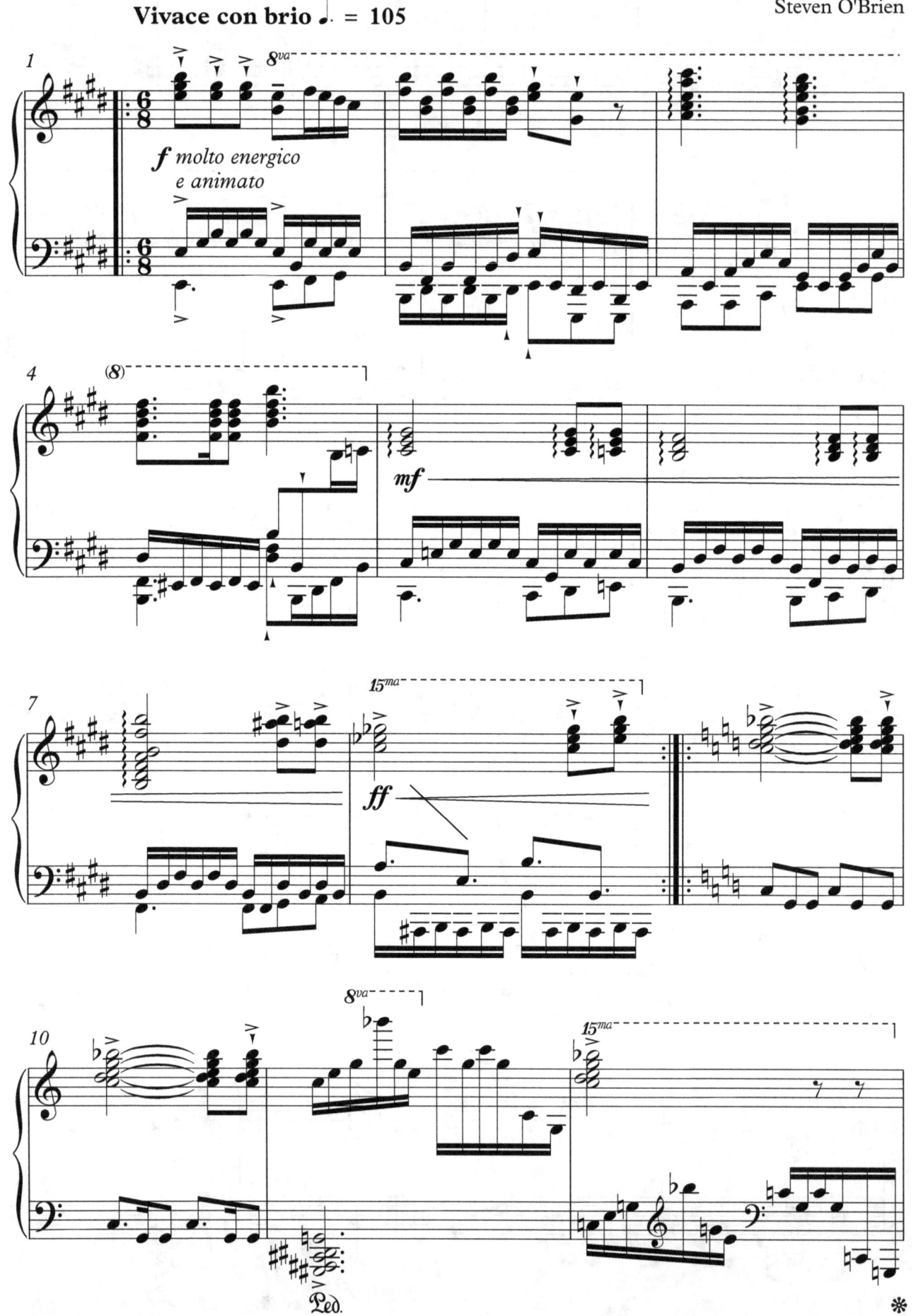

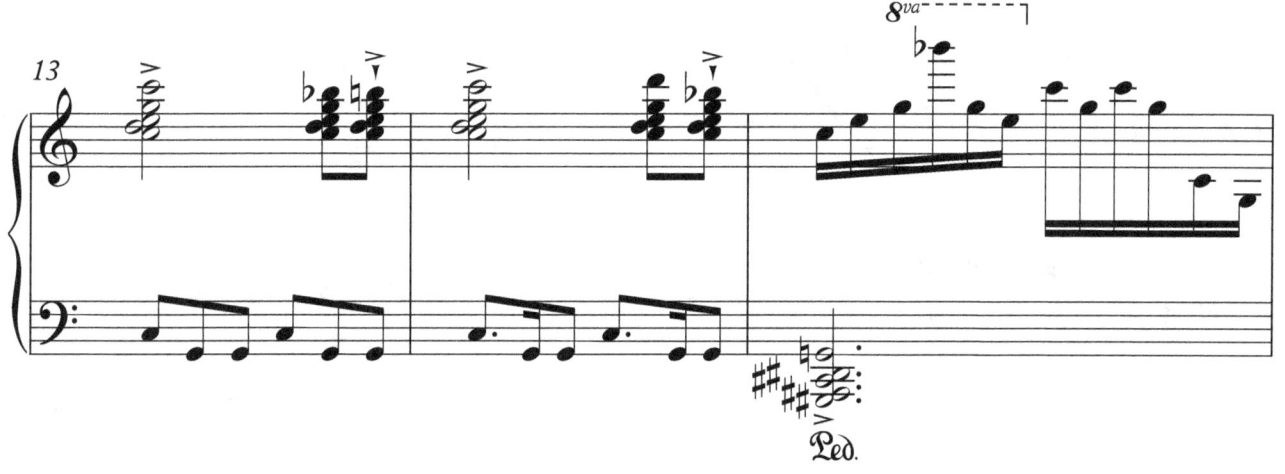
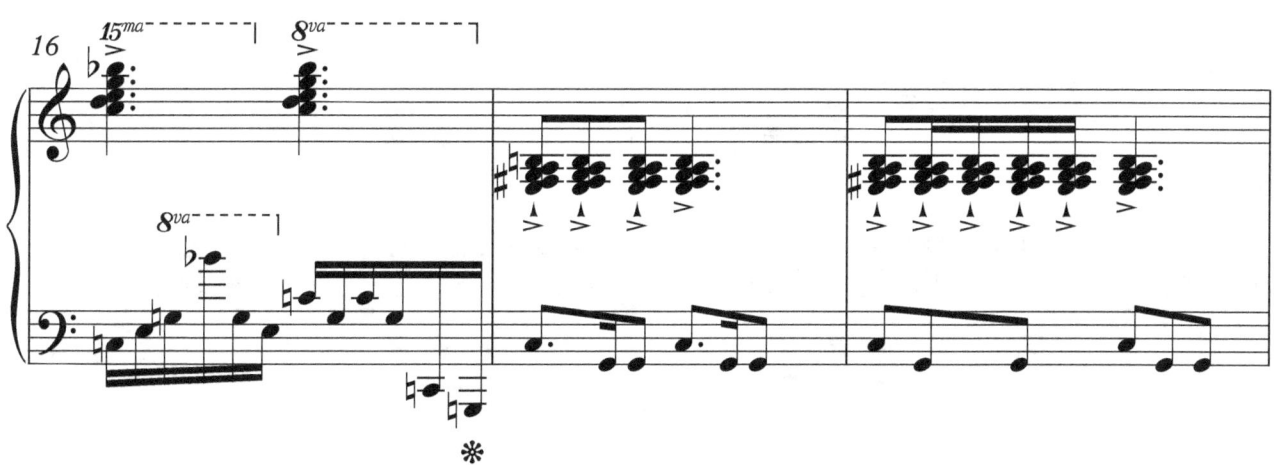

Prelude No. 10
in C-sharp minor, Op. 2j

Steven O'Brien

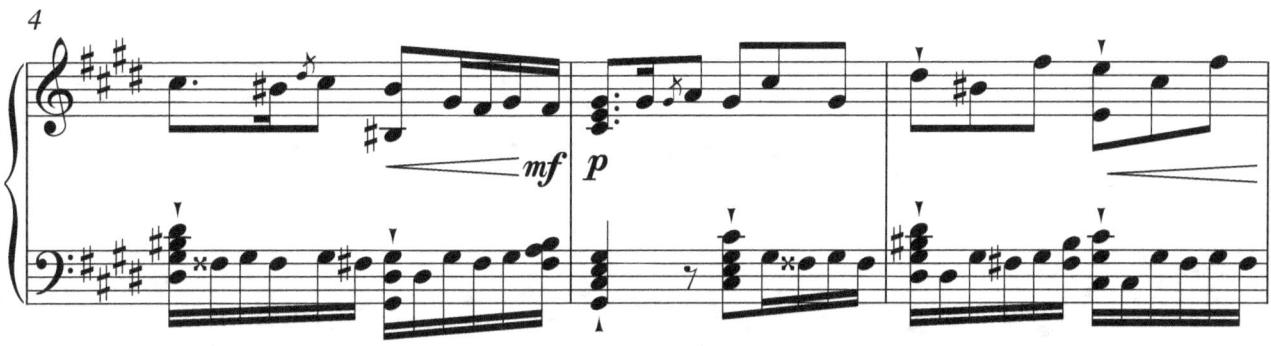
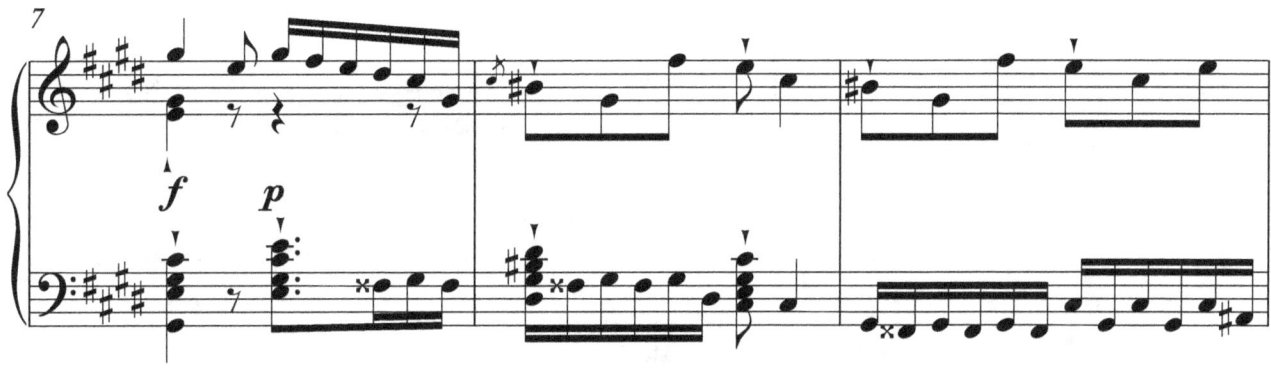
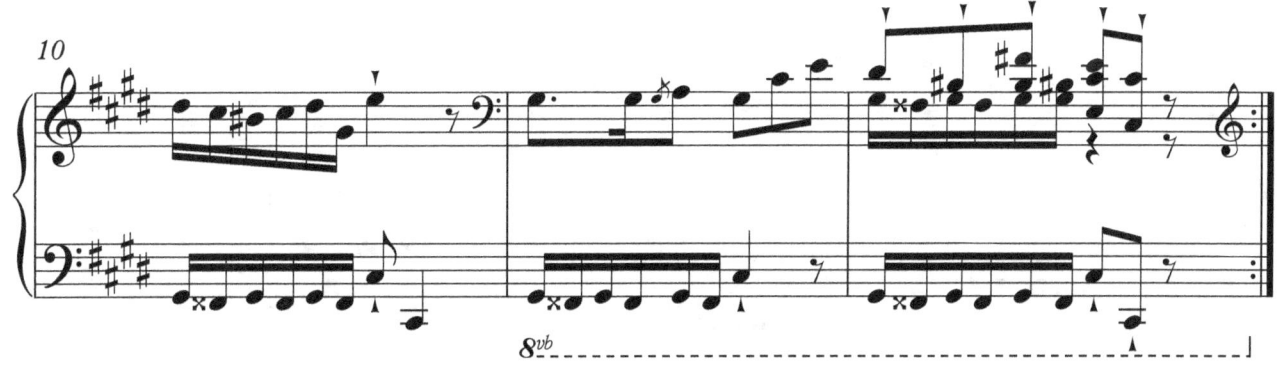

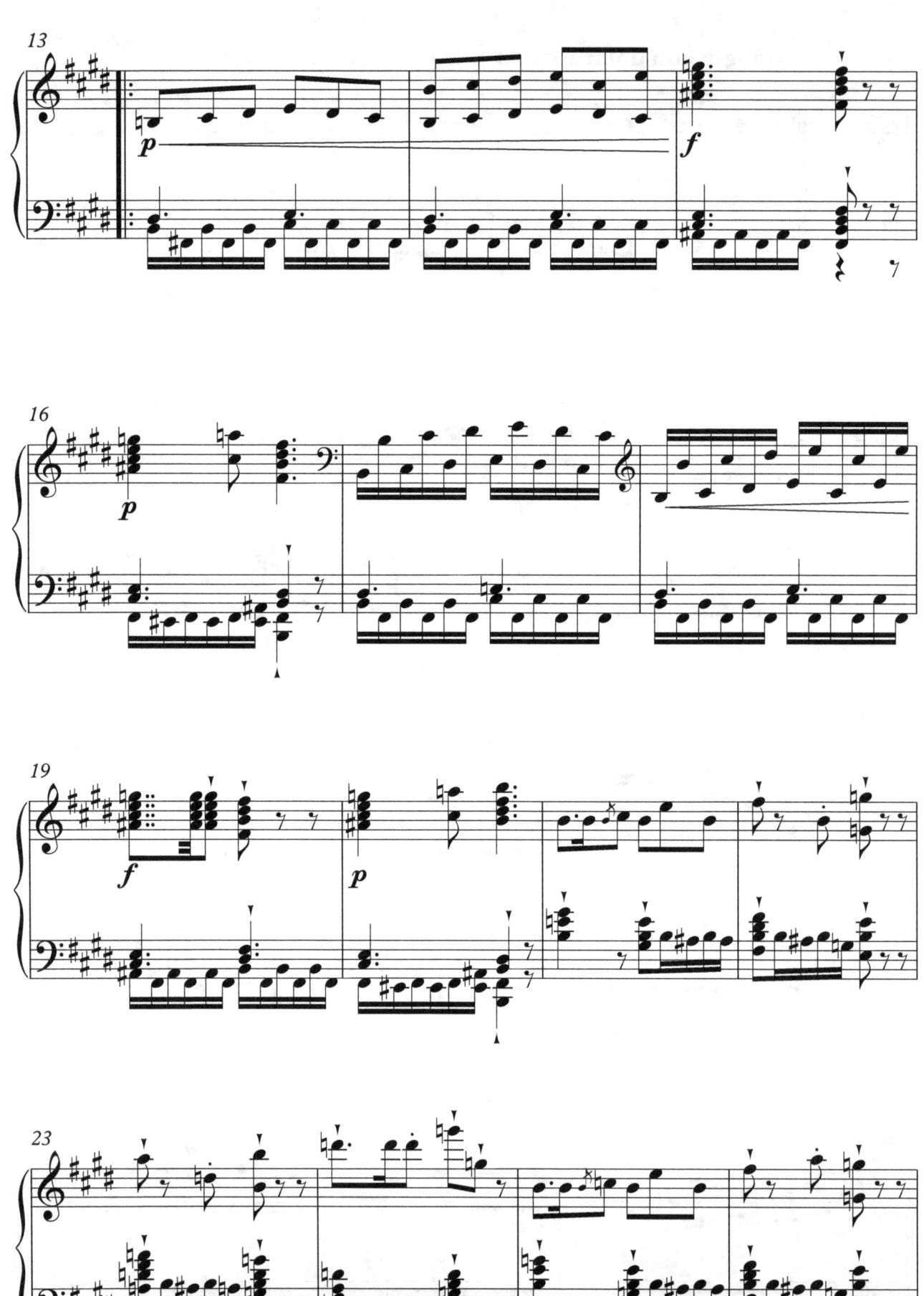

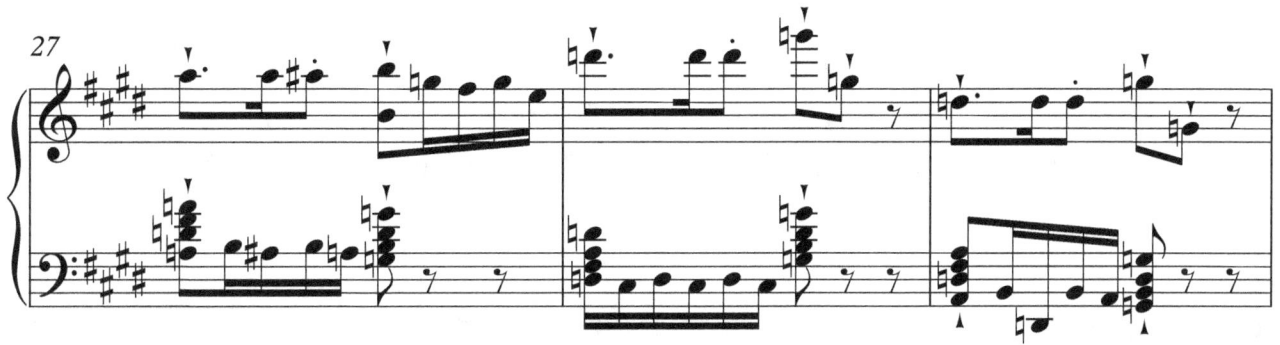
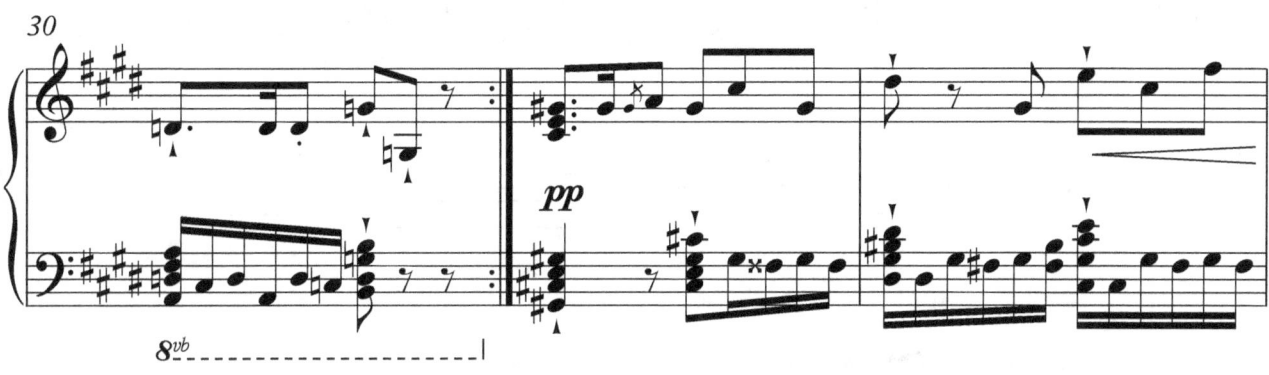
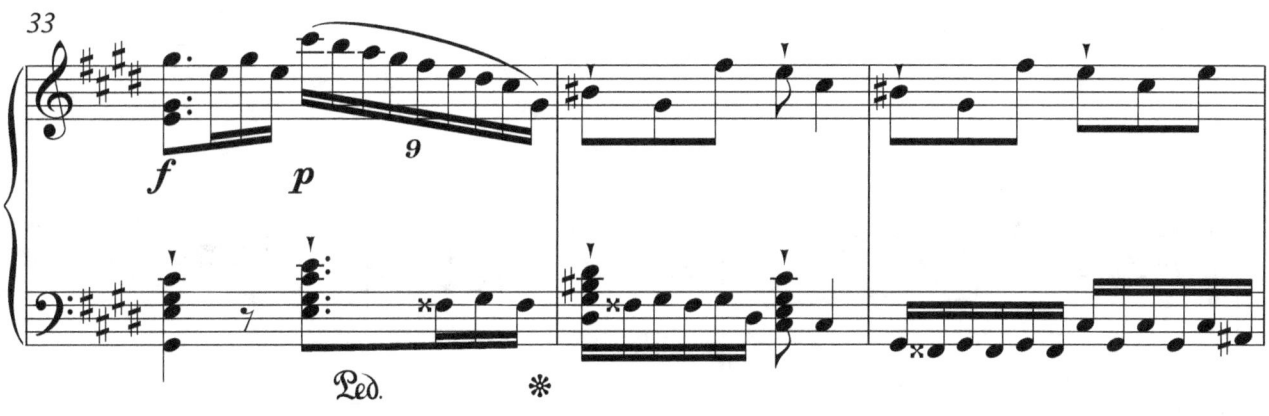
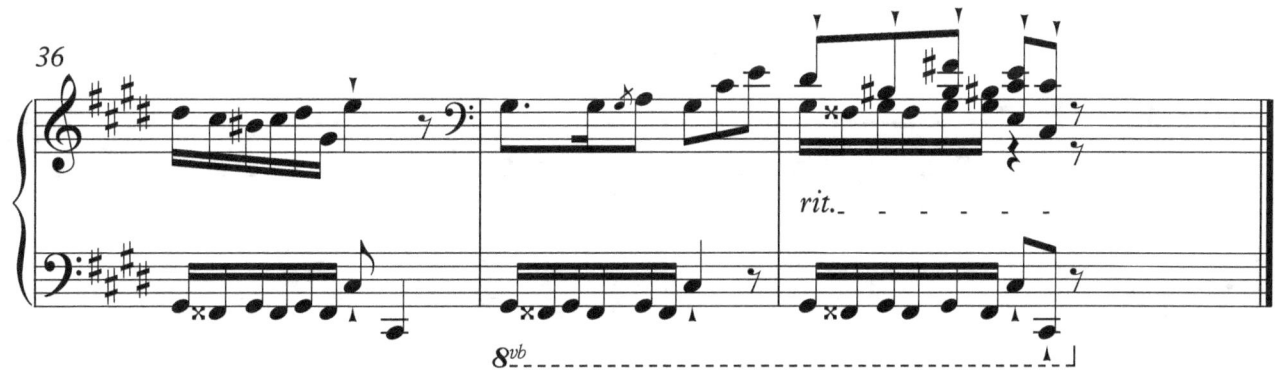

Prelude No. 11
in B major, Op. 2k

Steven O'Brien

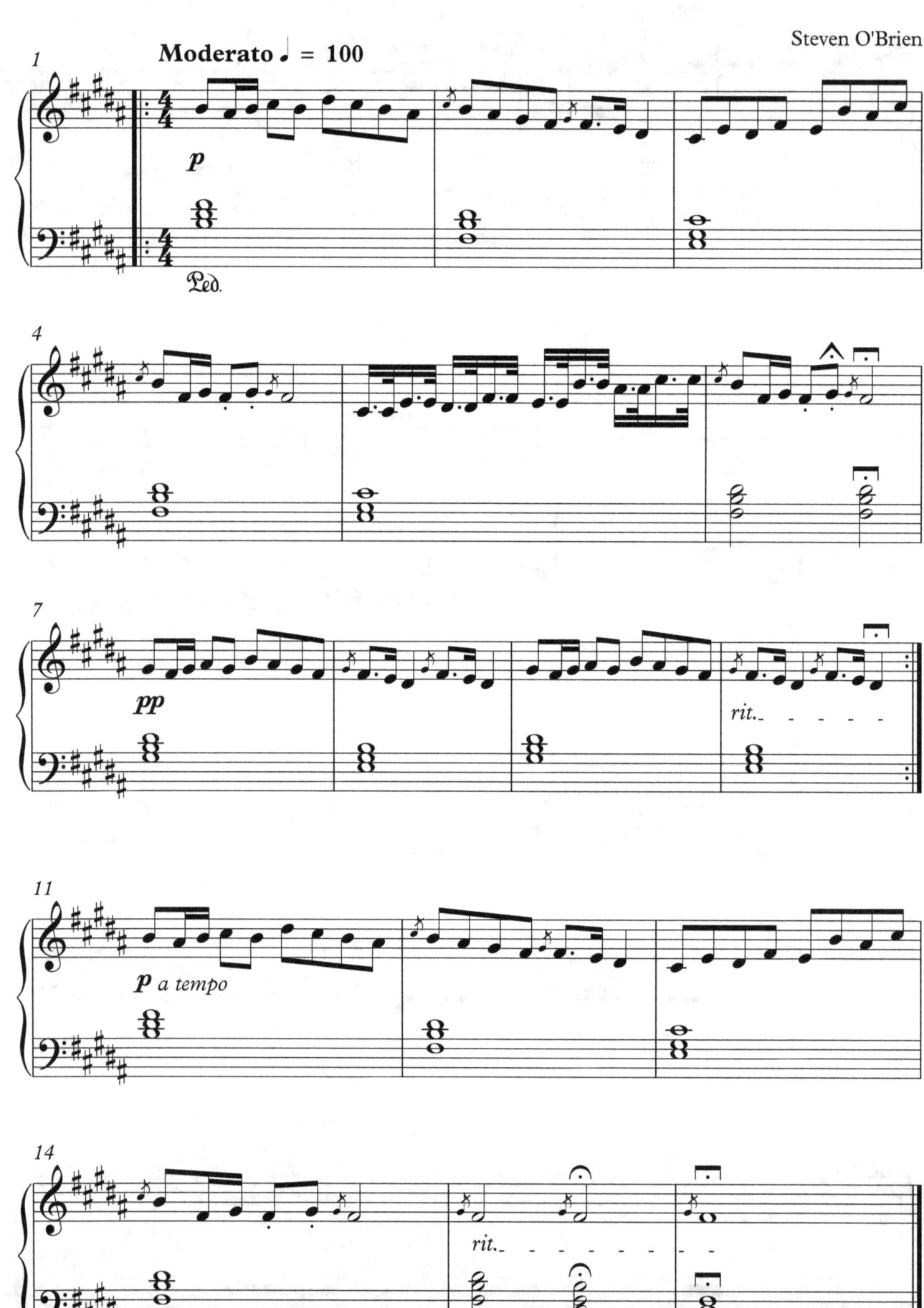

Prelude No. 12
in G-sharp minor, Op. 21

Steven O'Brien

Largo grave e sostenuto ♩ = 55

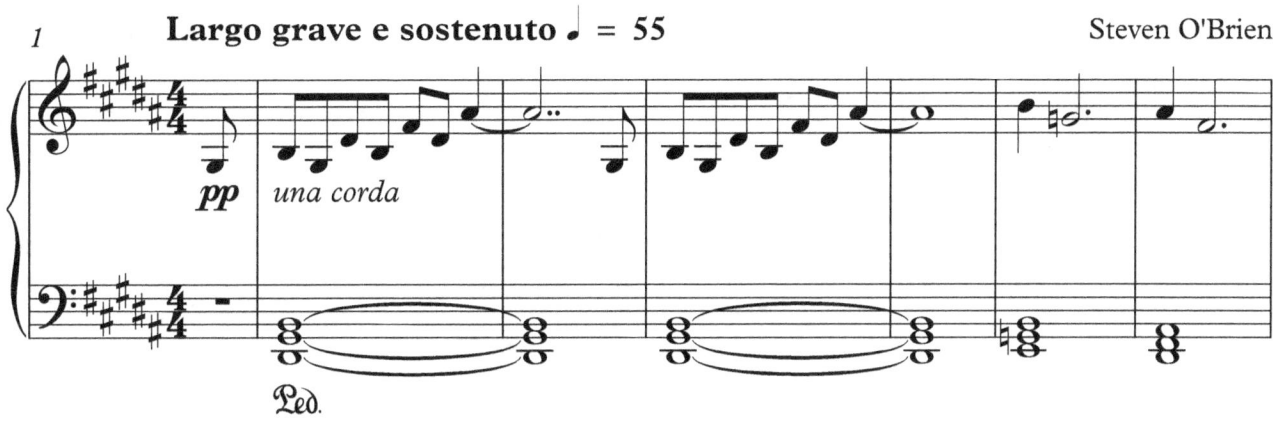
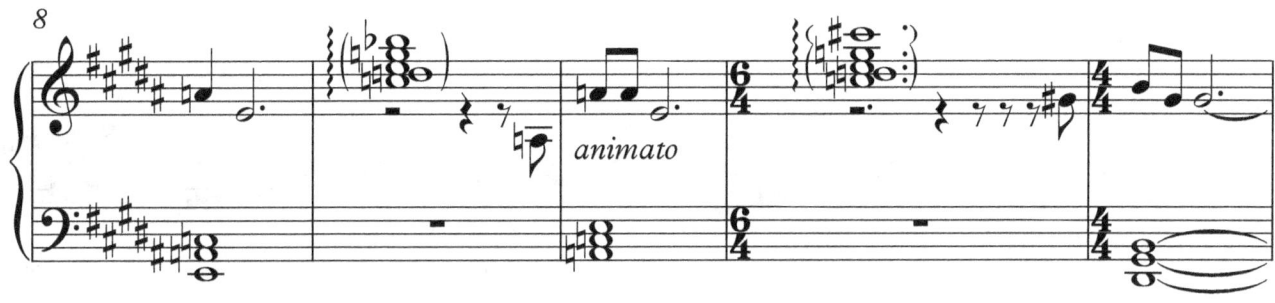
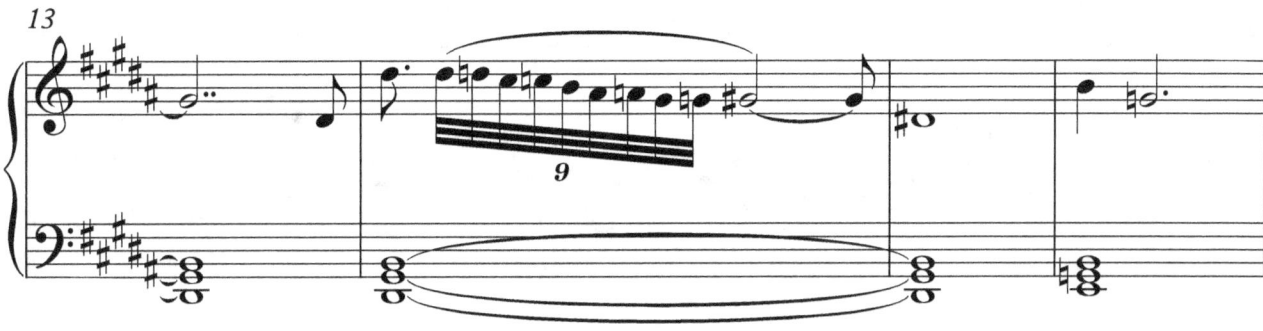
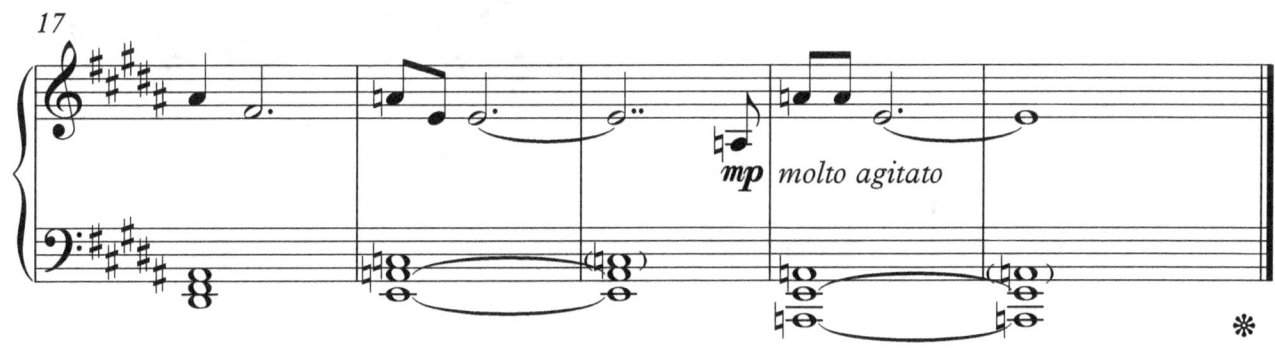

Prelude No. 13
in F-sharp major, Op. 2m

Steven O'Brien

Allegro giocoso ♩ = 170

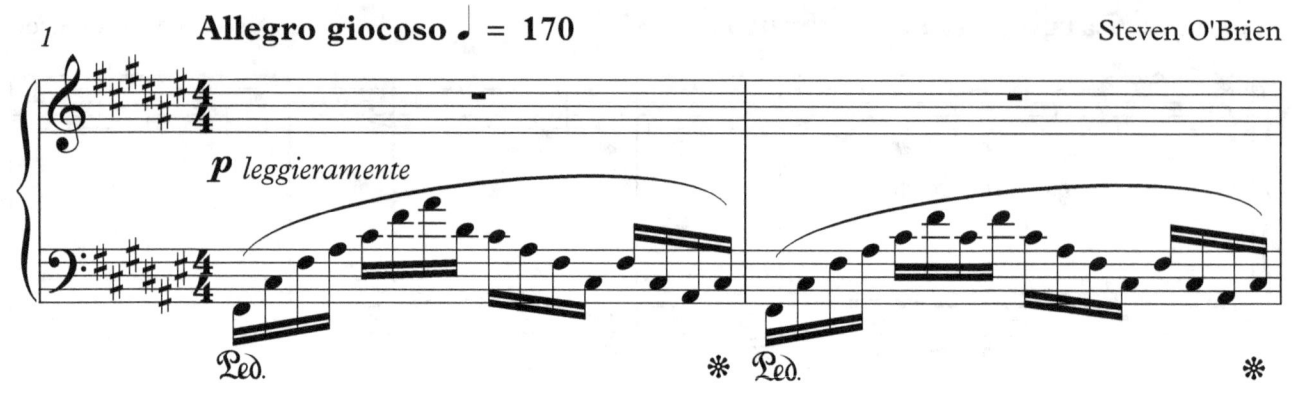
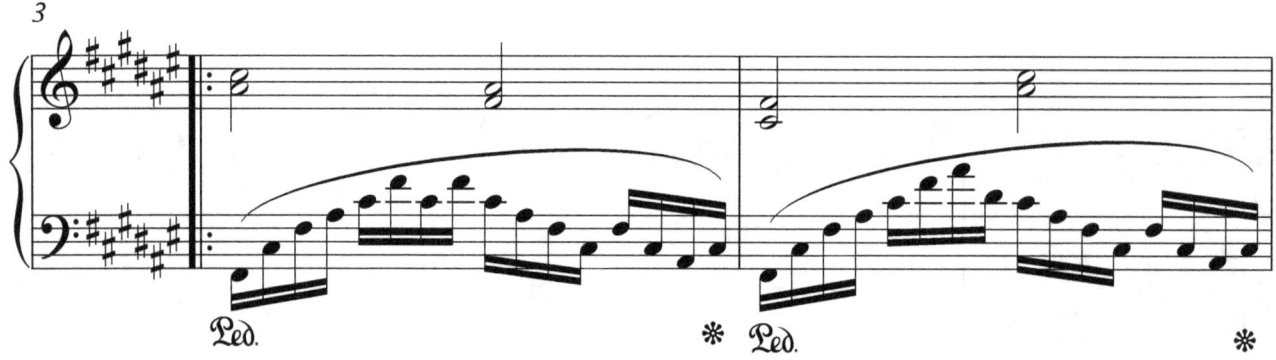
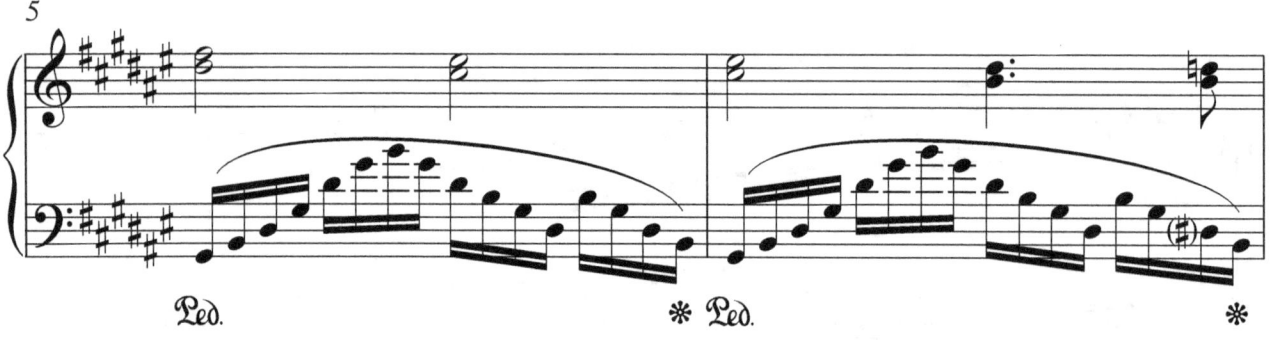
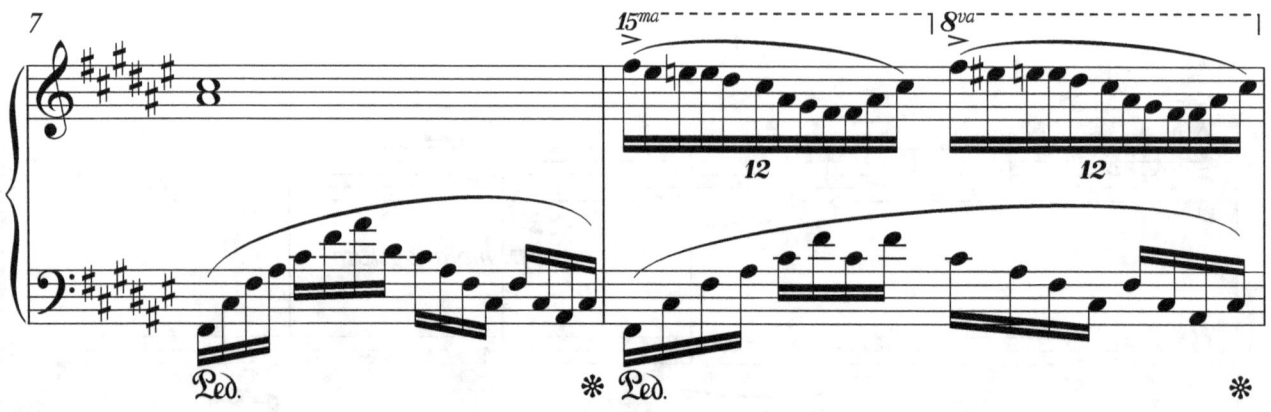

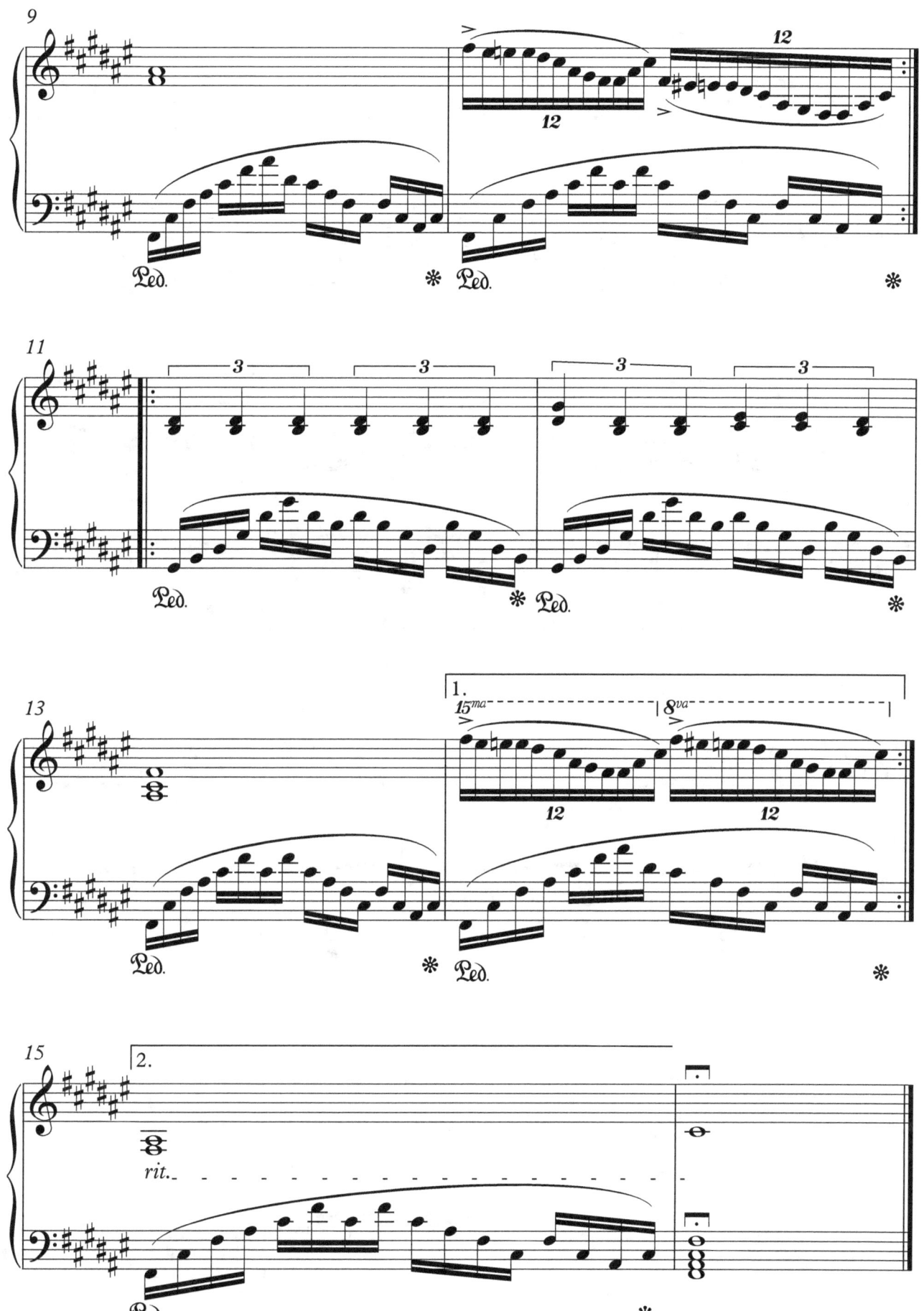

Prelude No. 14
in E-flat minor, Op. 2n

Steven O'Brien

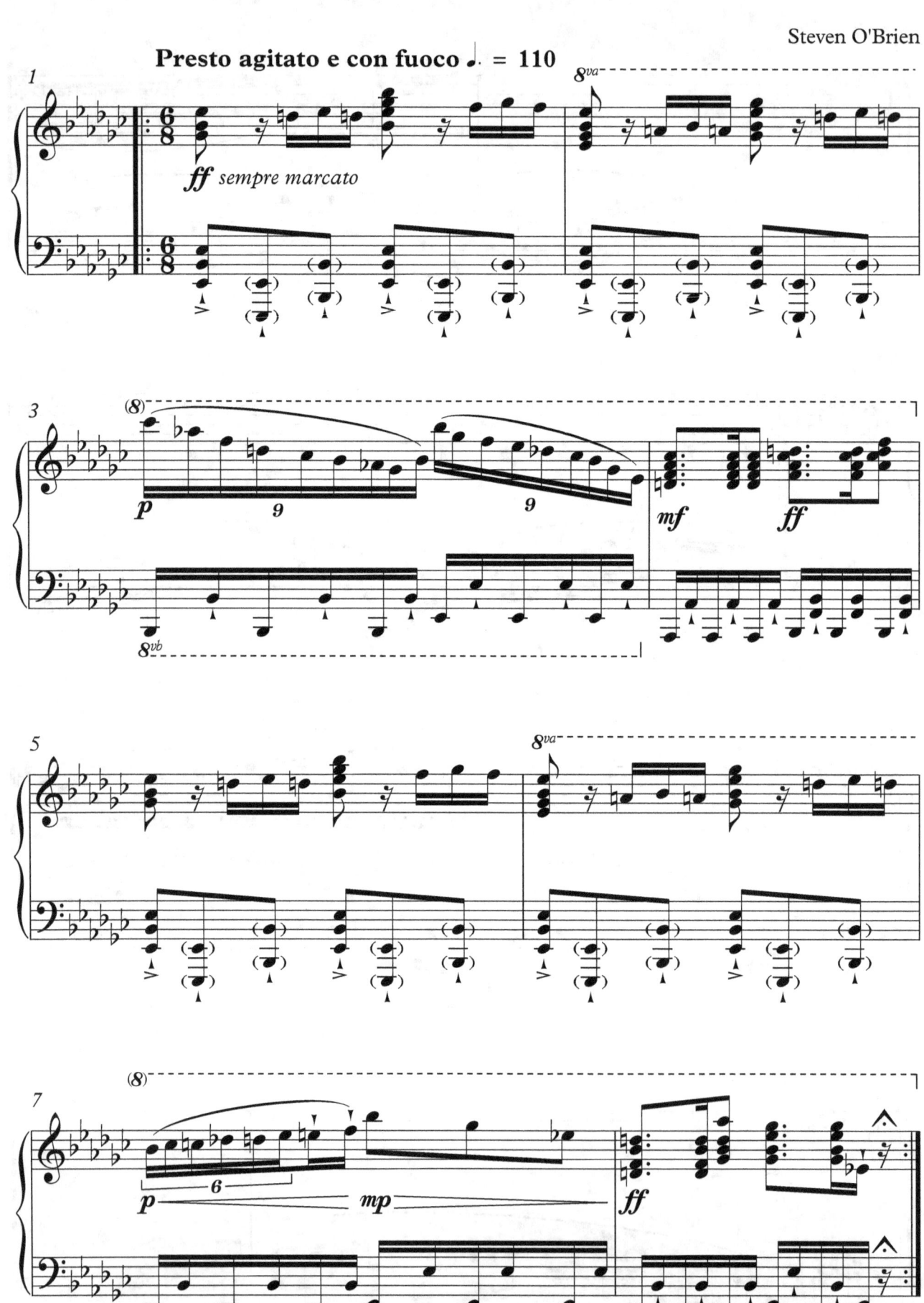

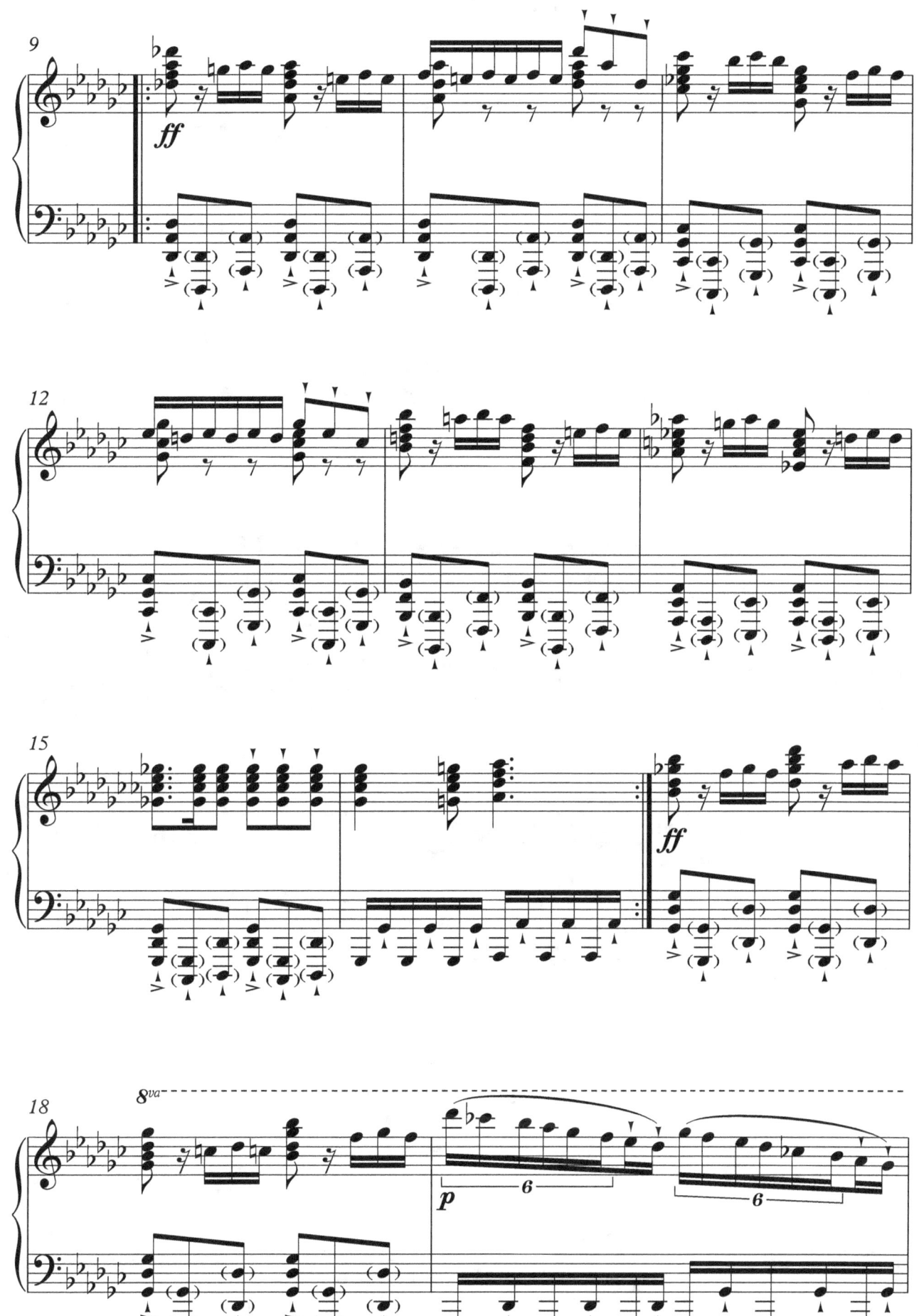

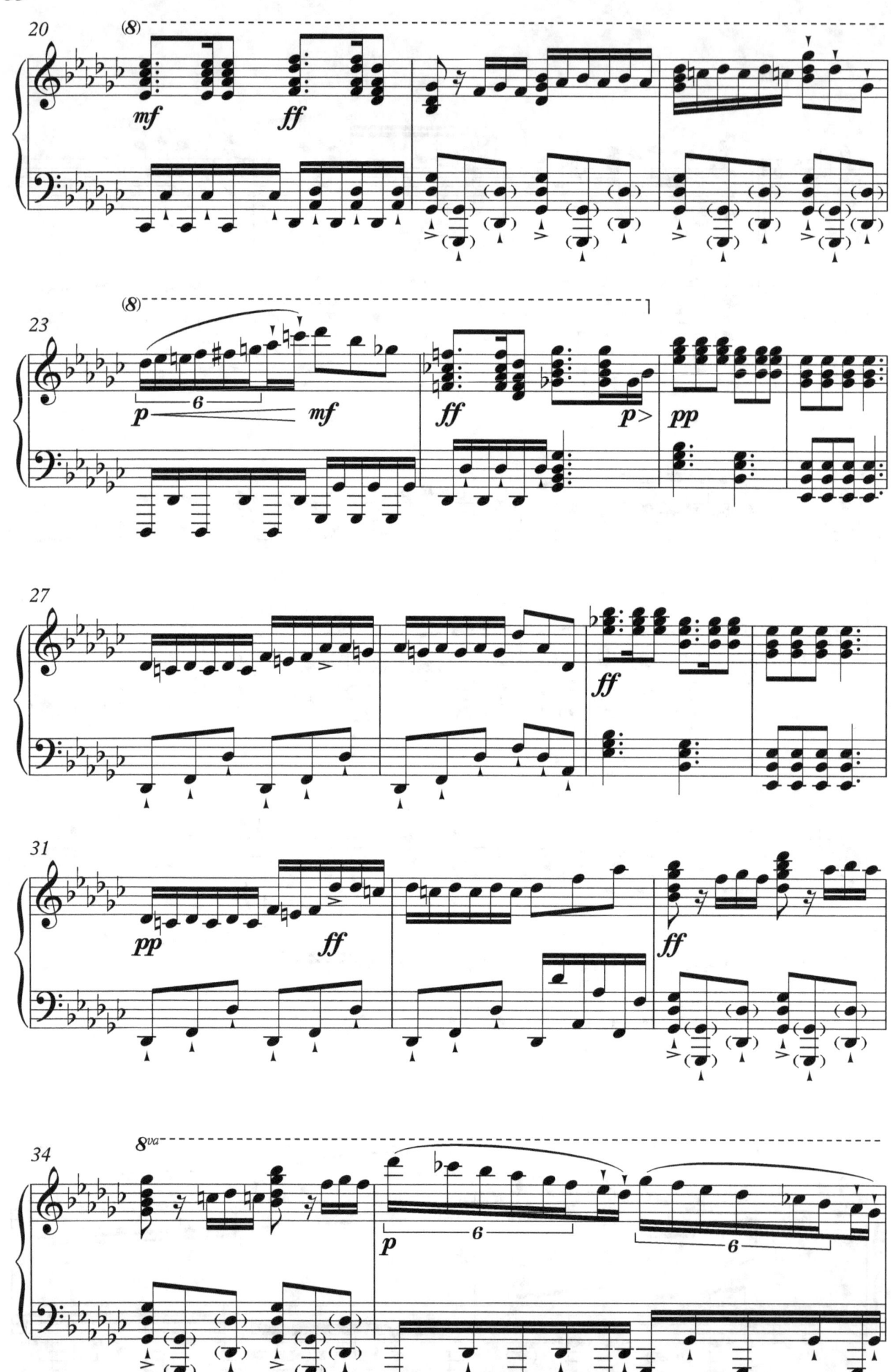

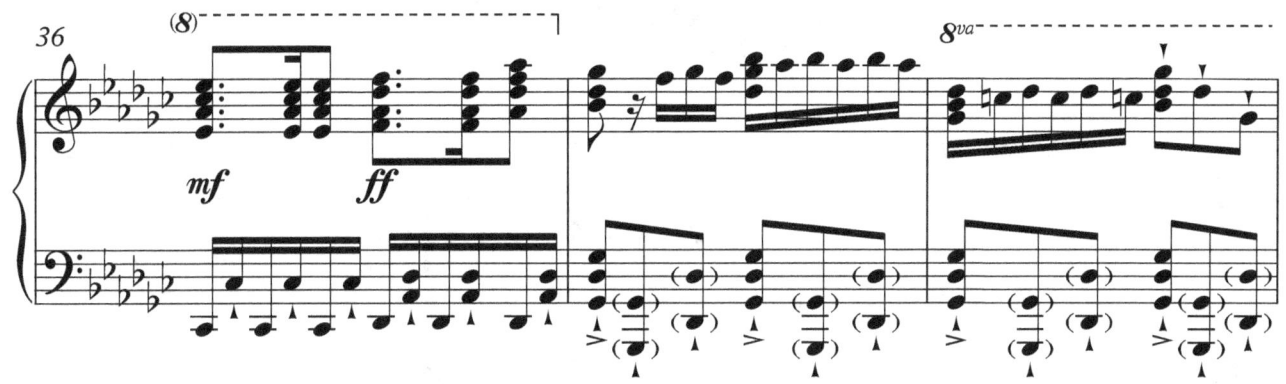
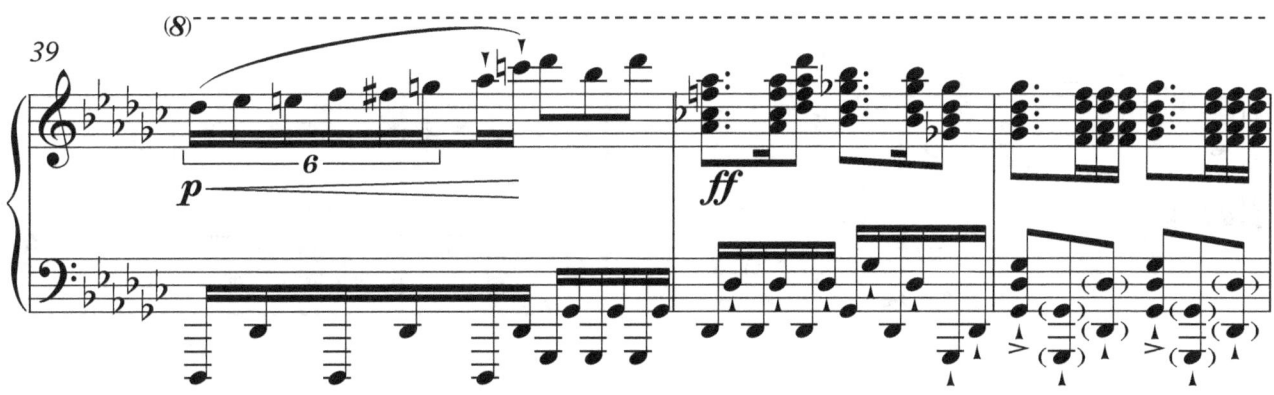
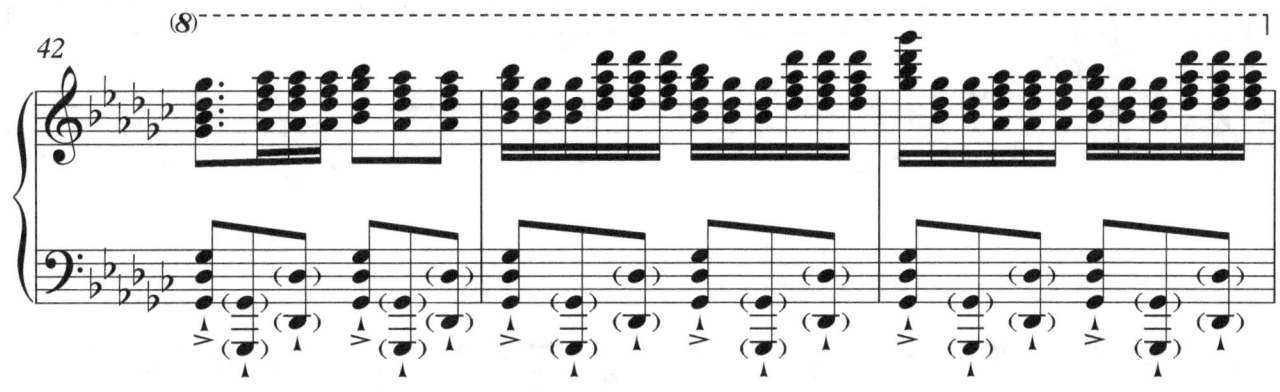
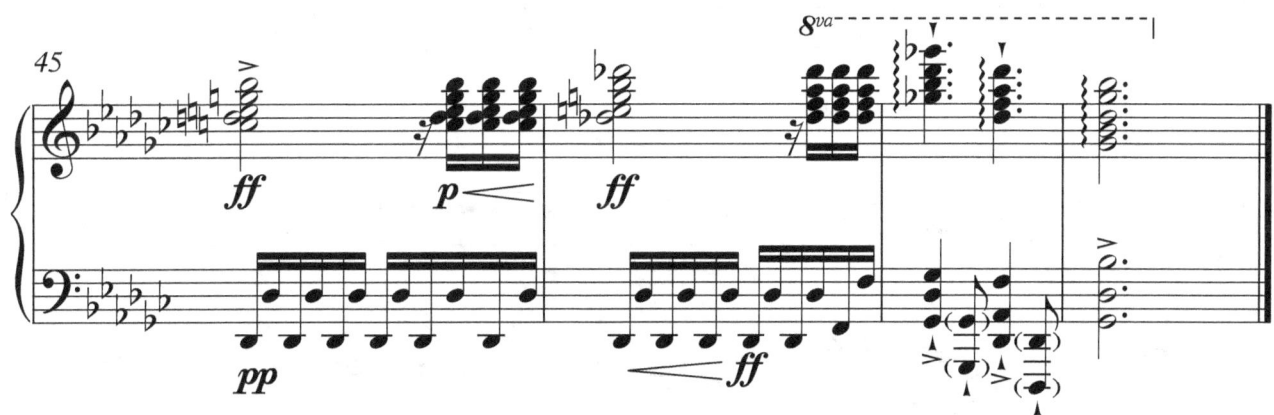

Prelude No. 15
in D-flat major, Op. 20

Steven O'Brien

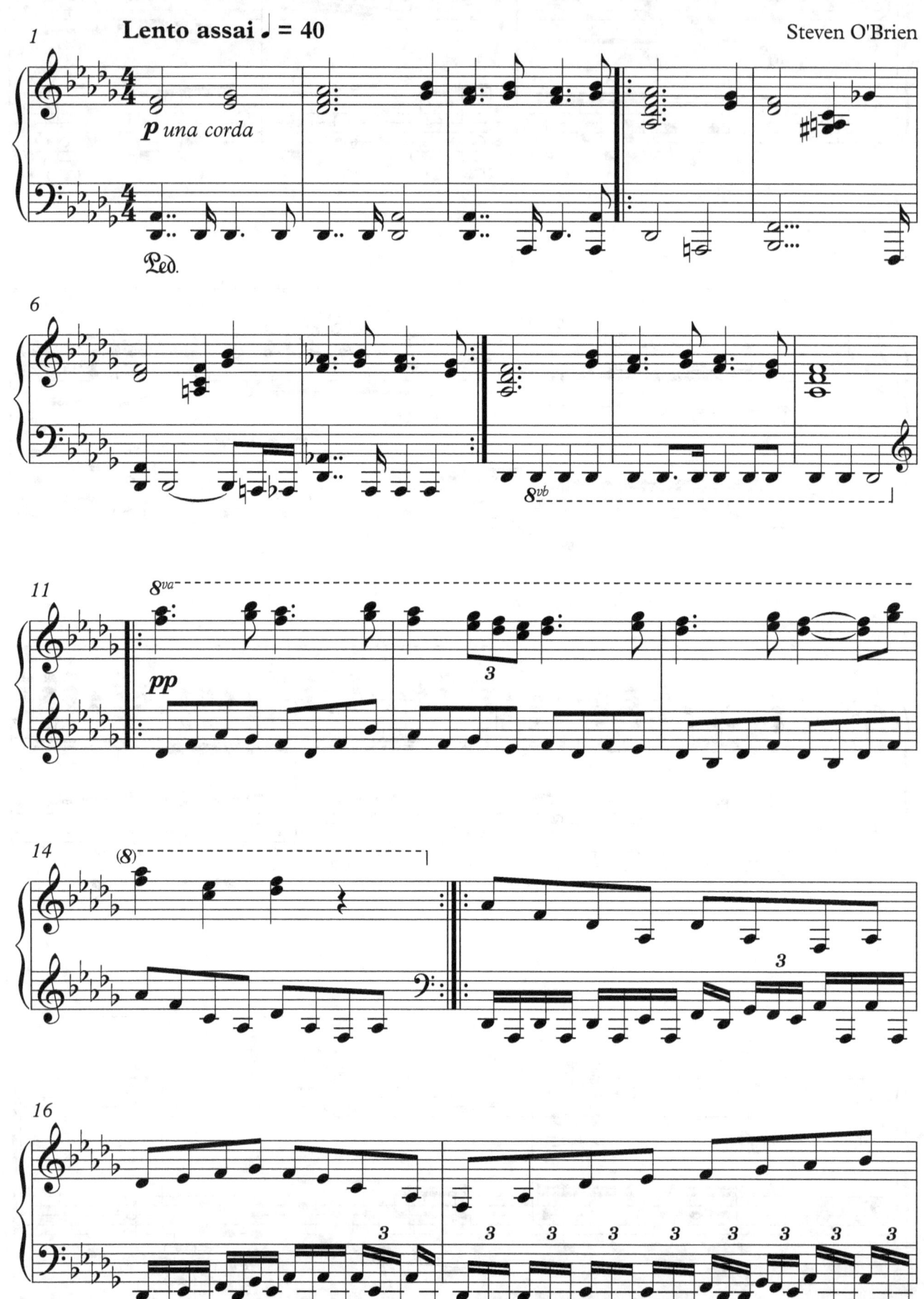

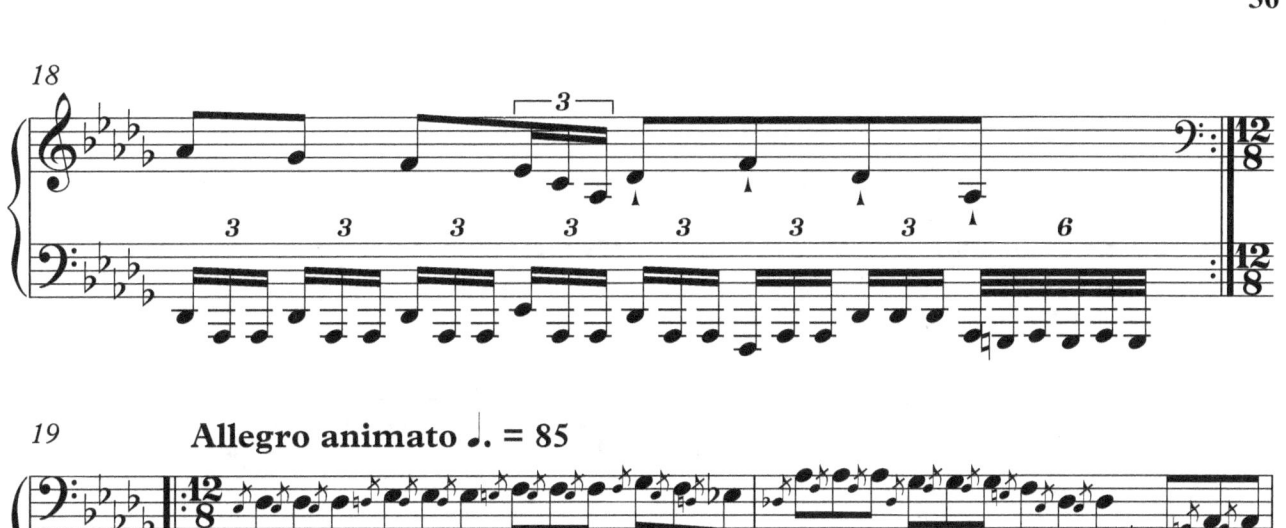
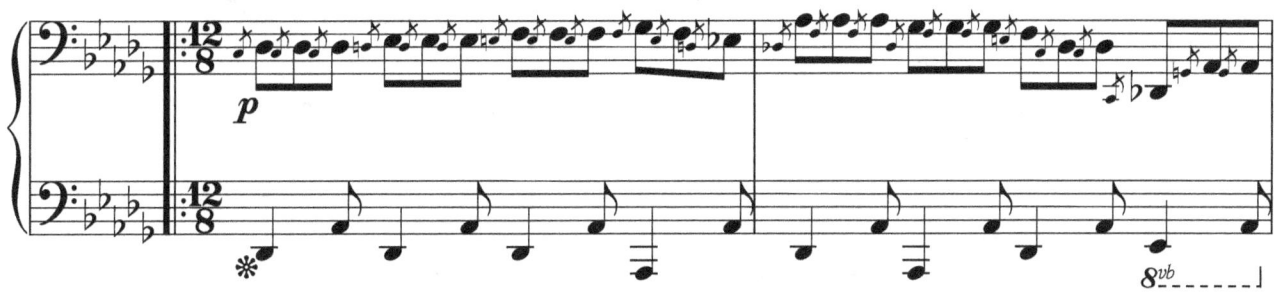
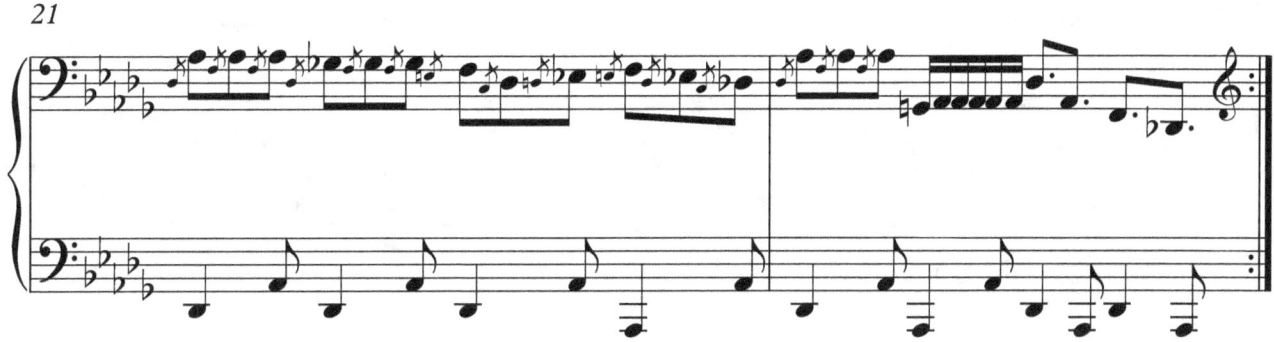
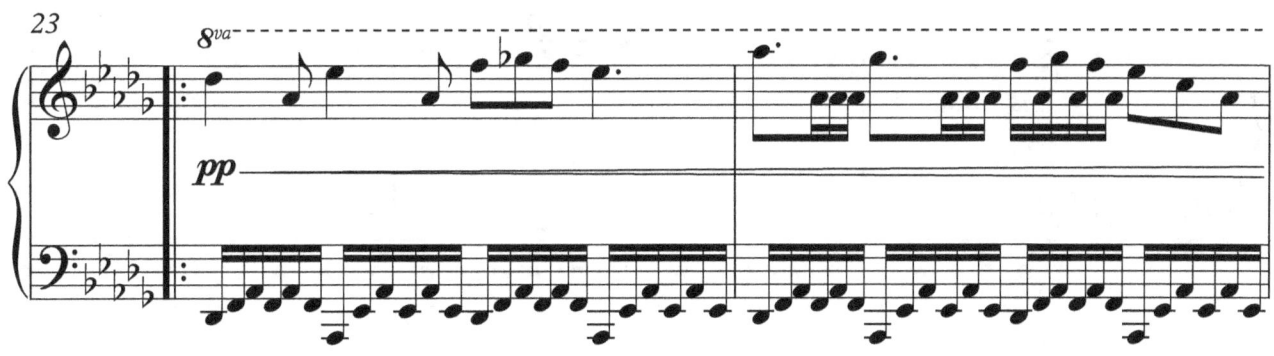
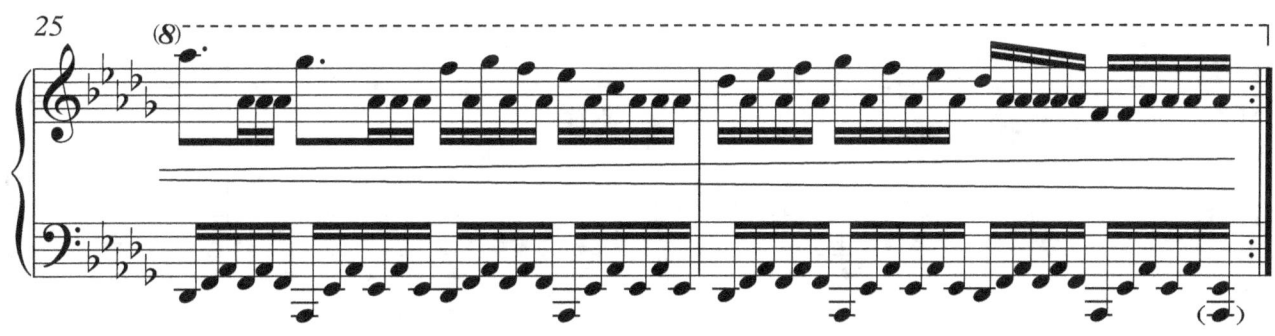

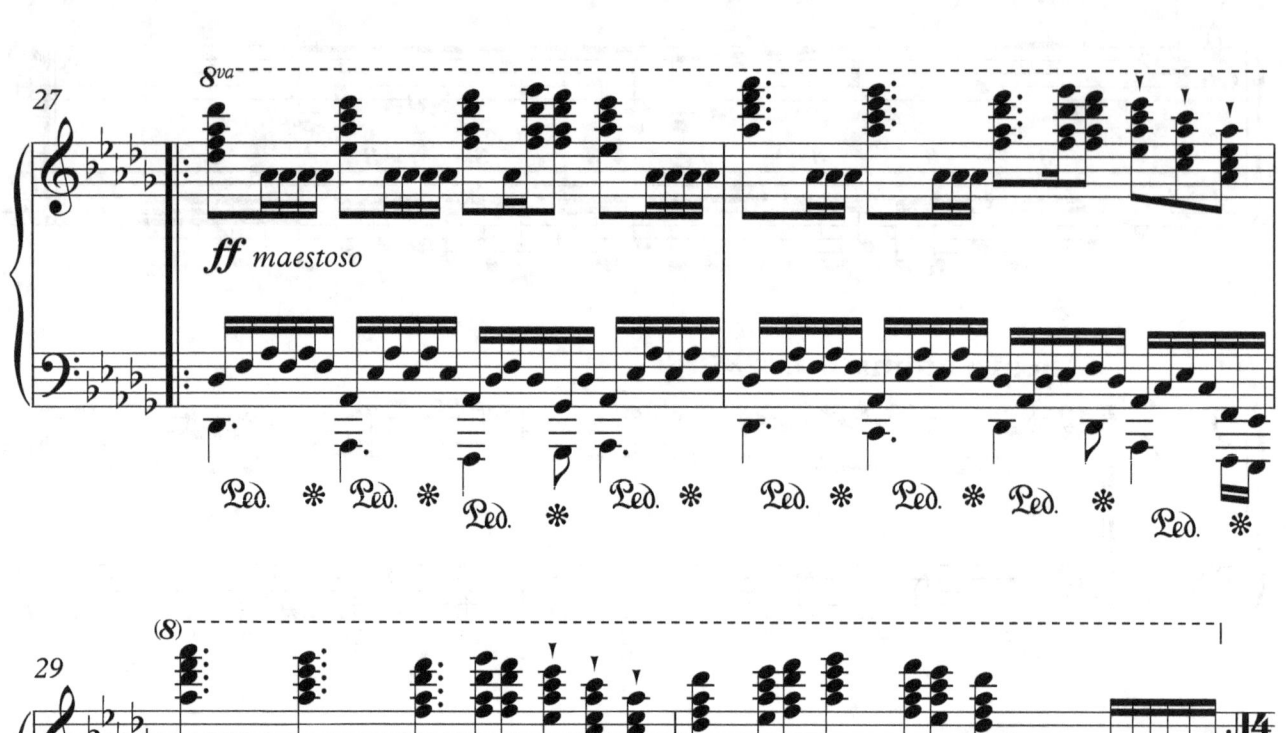
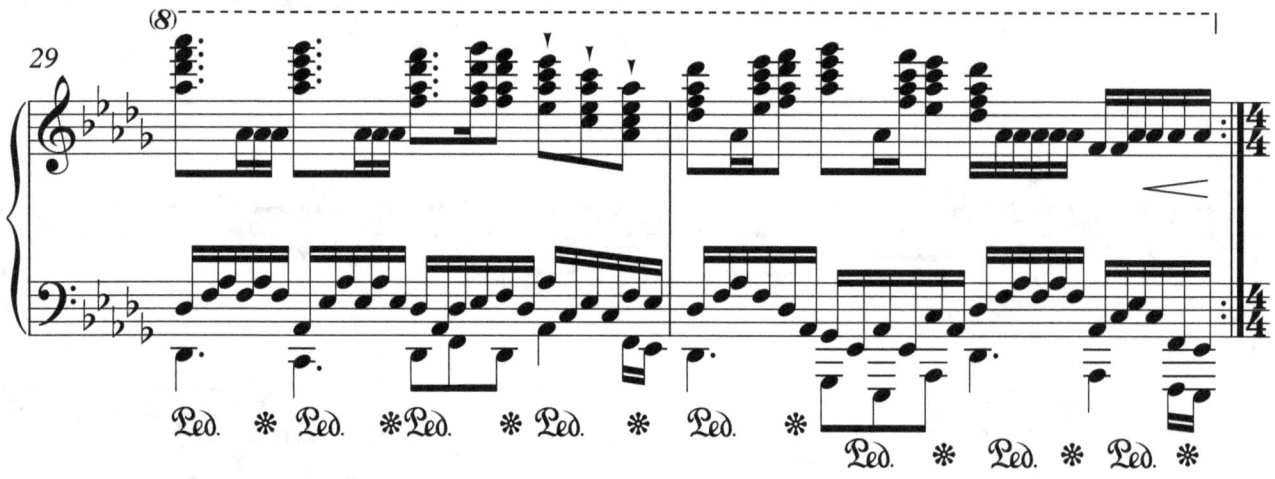
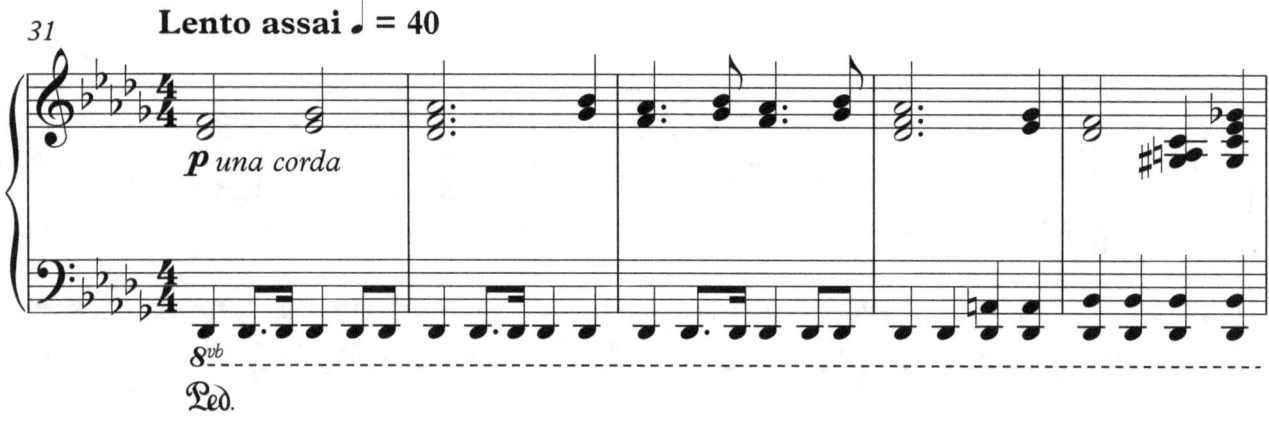
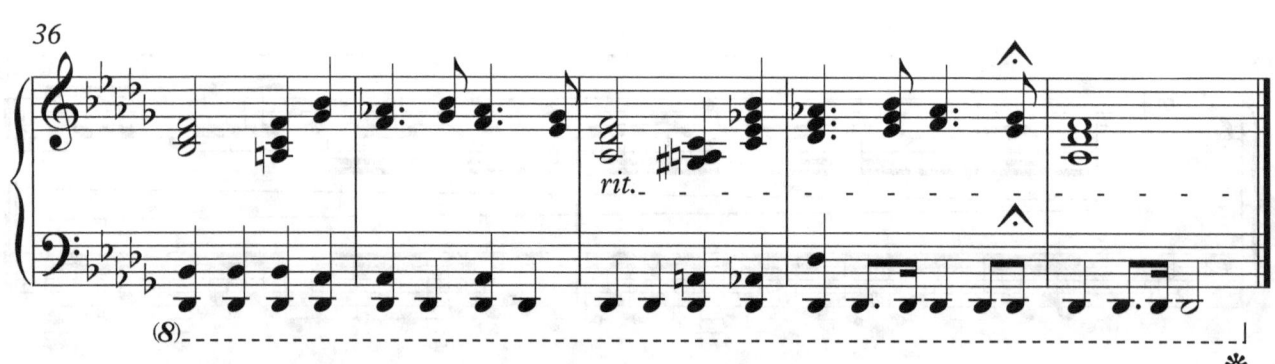

Prelude No. 16
in B-flat minor, Op. 2p

Steven O'Brien

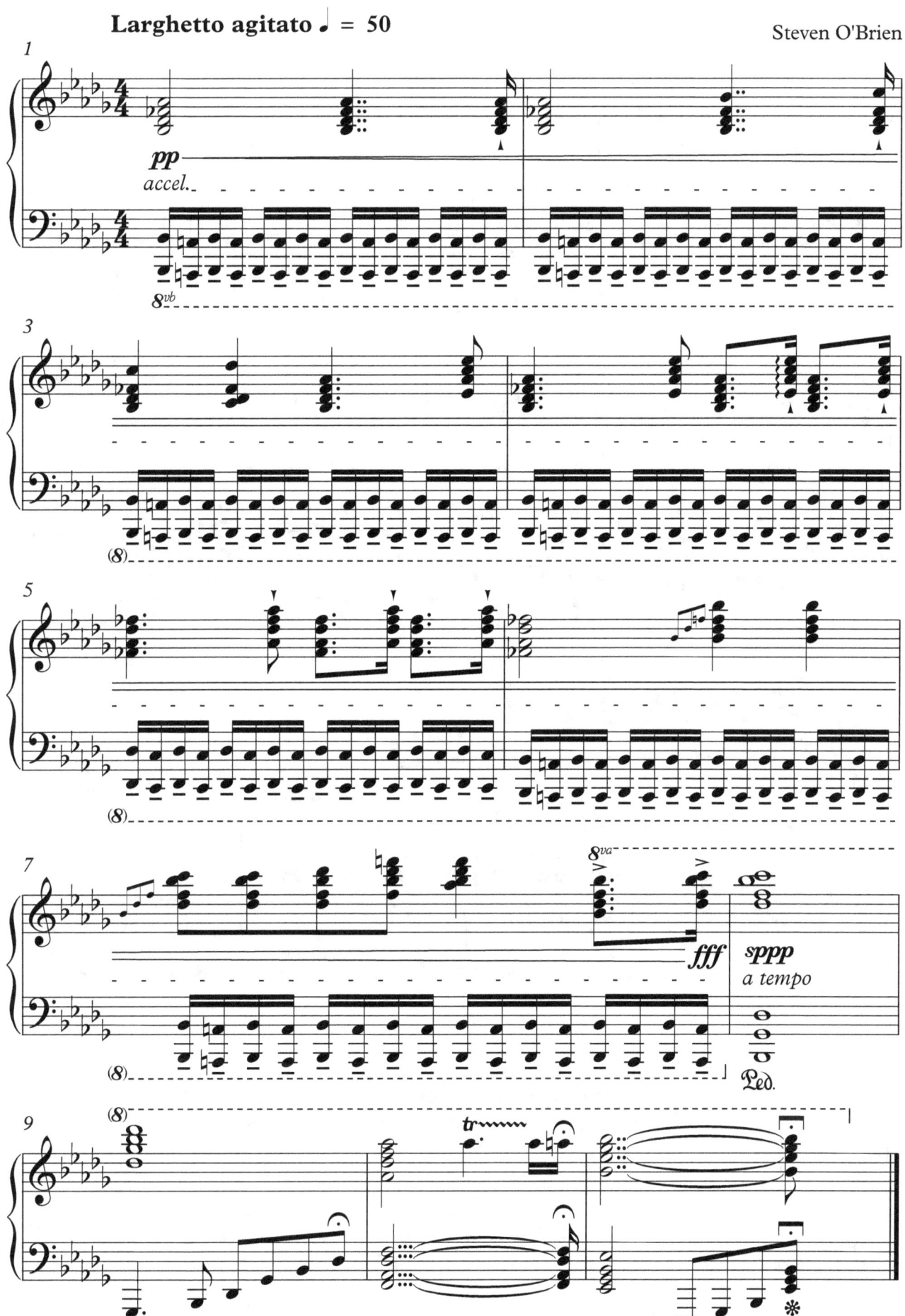

Prelude No. 17
in A-flat major, Op. 2q

Steven O'Brien

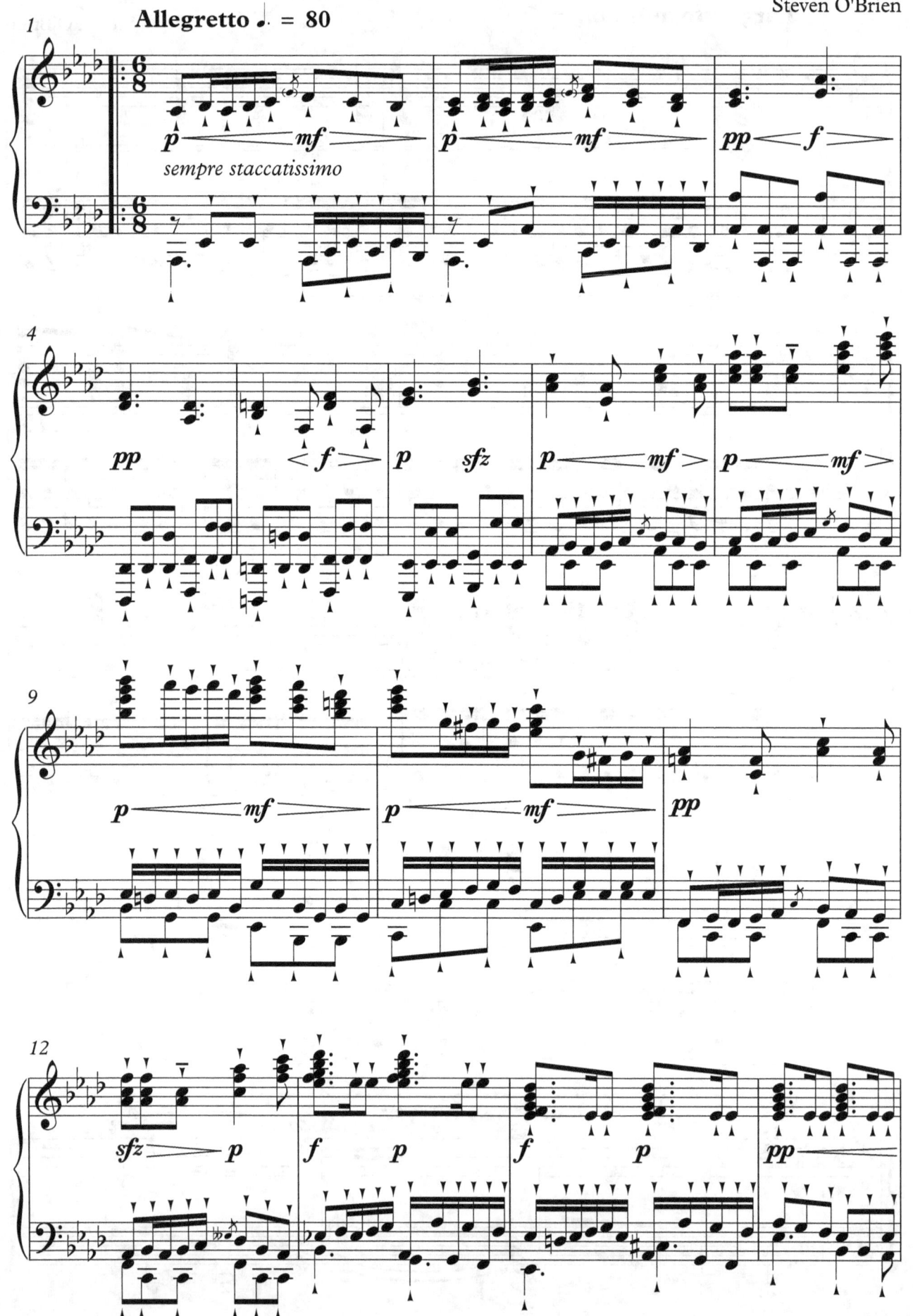

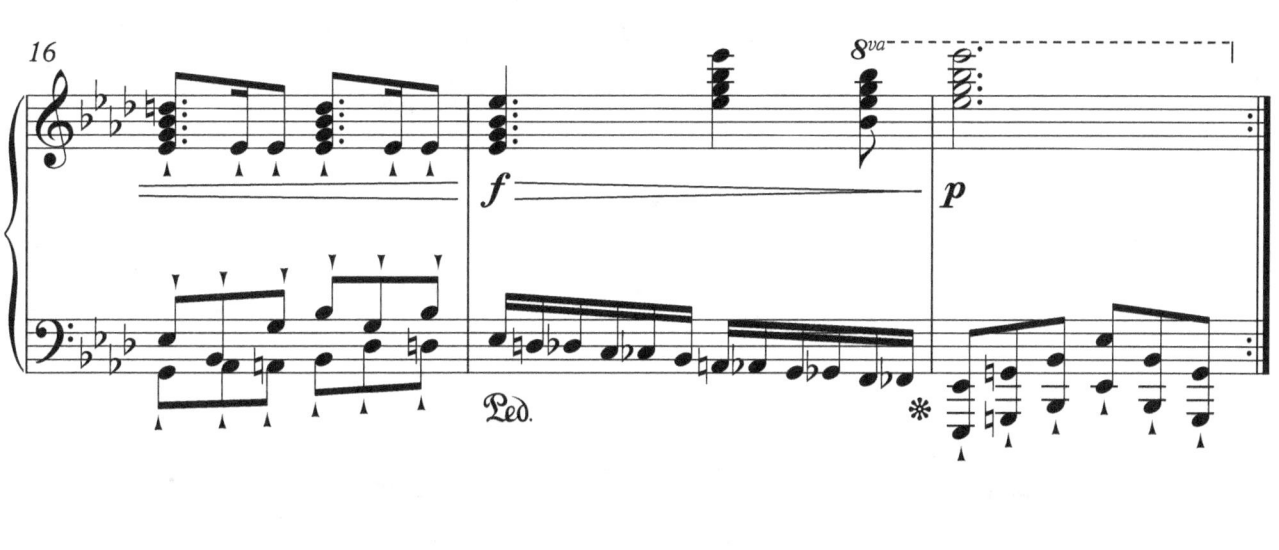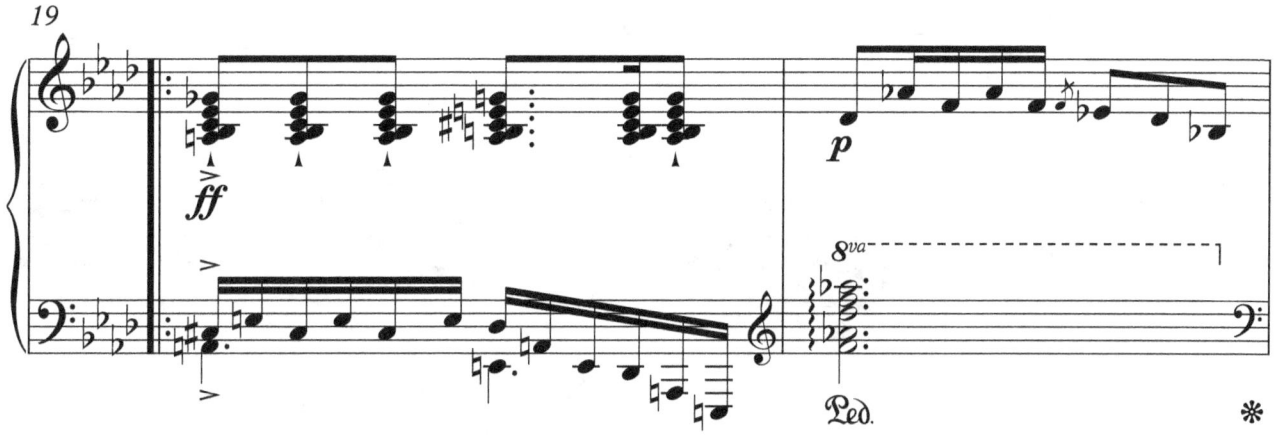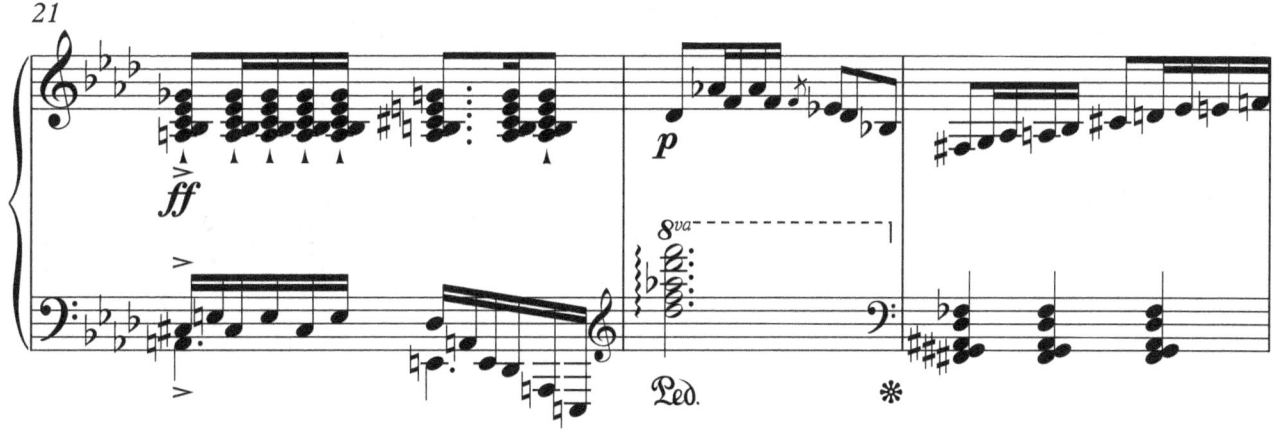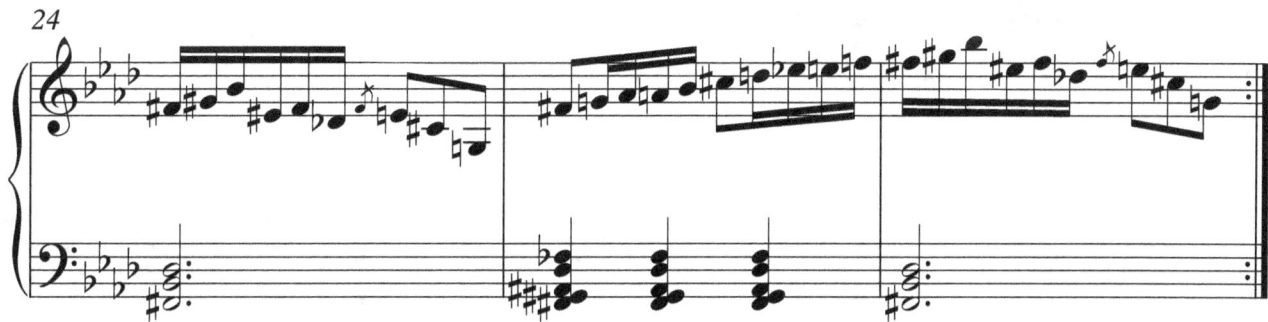

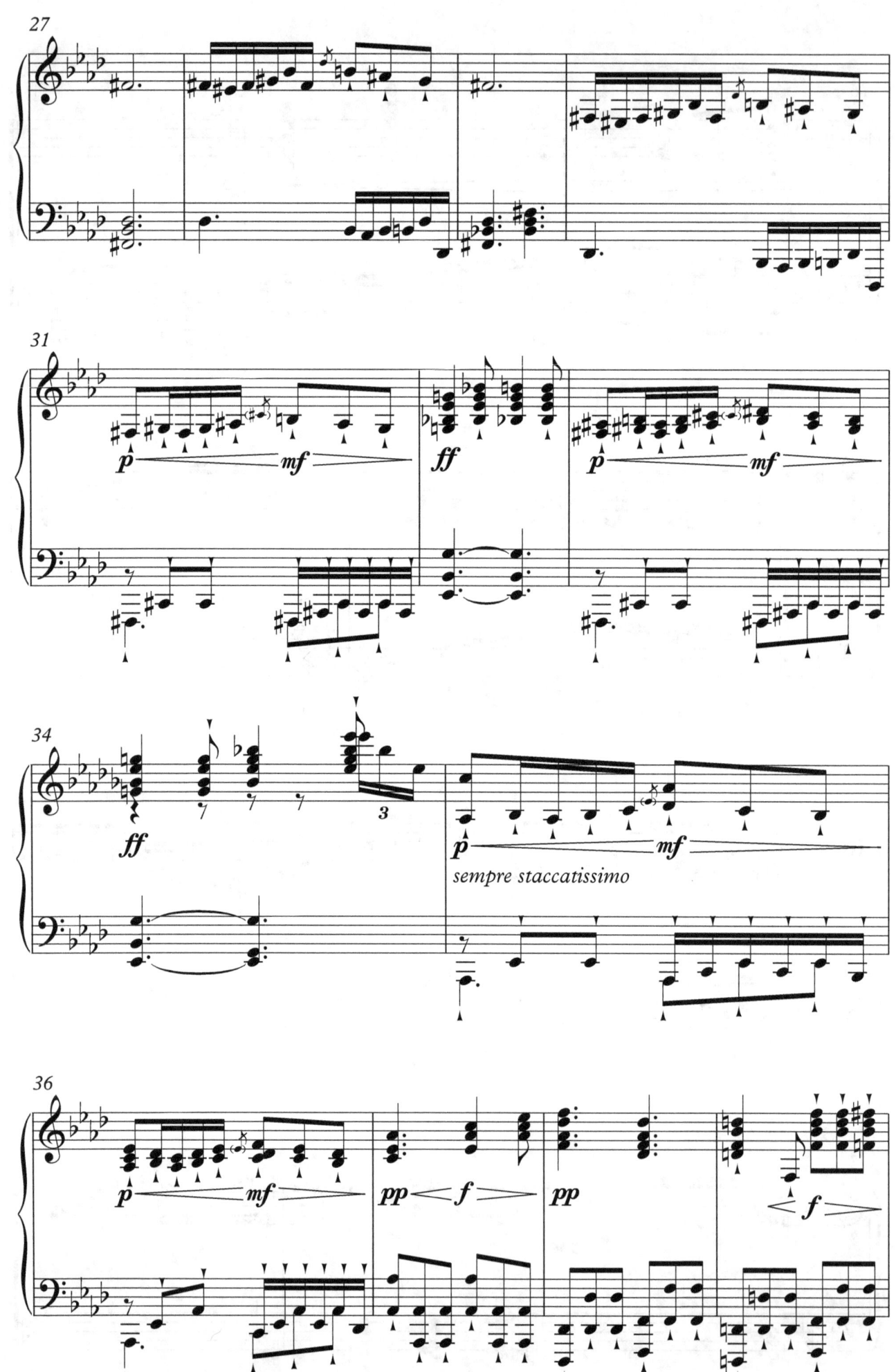

Prelude No. 18
in F minor, Op. 2r

Steven O'Brien

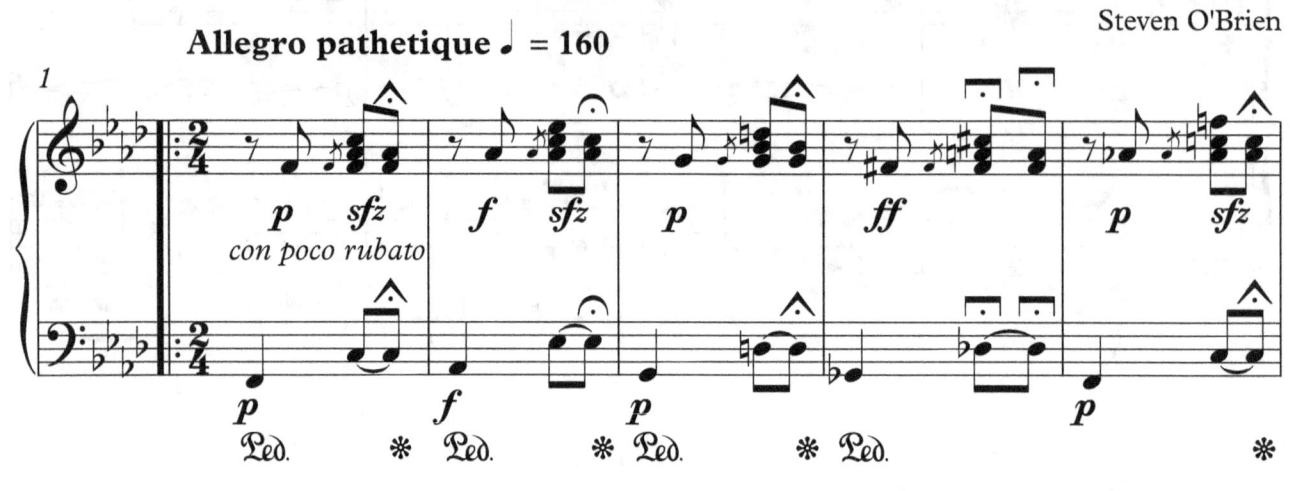
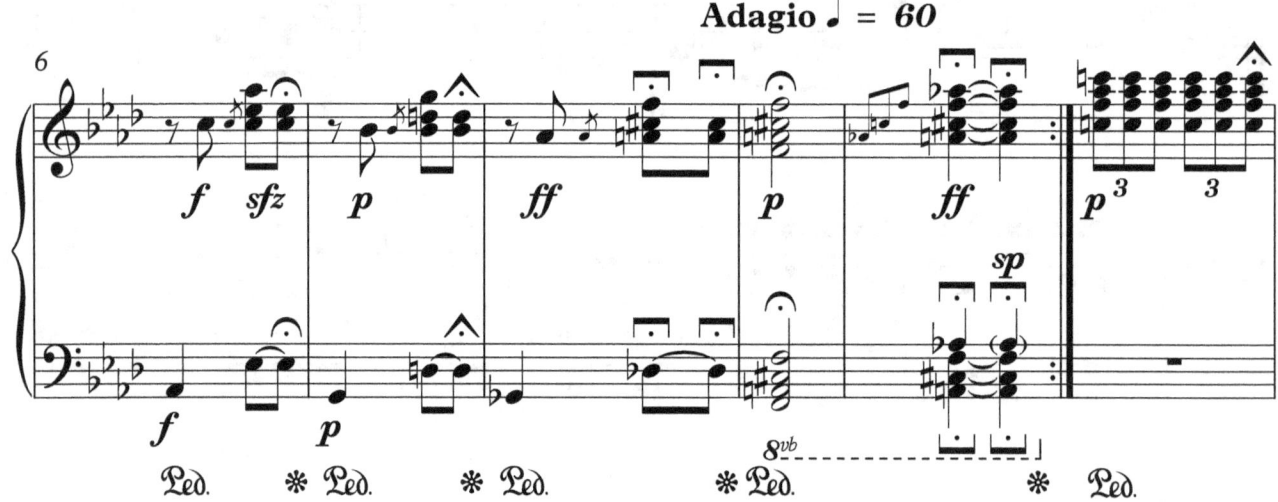
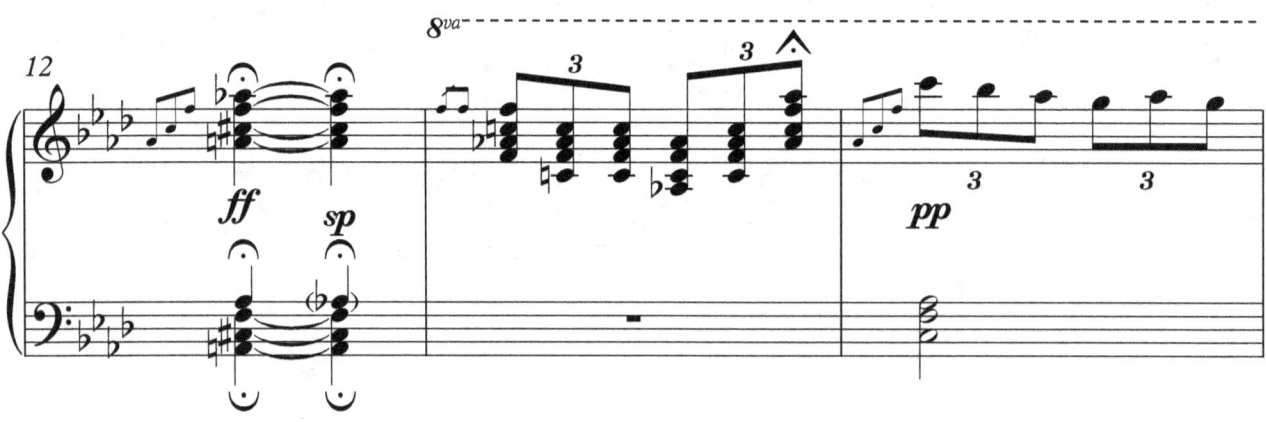
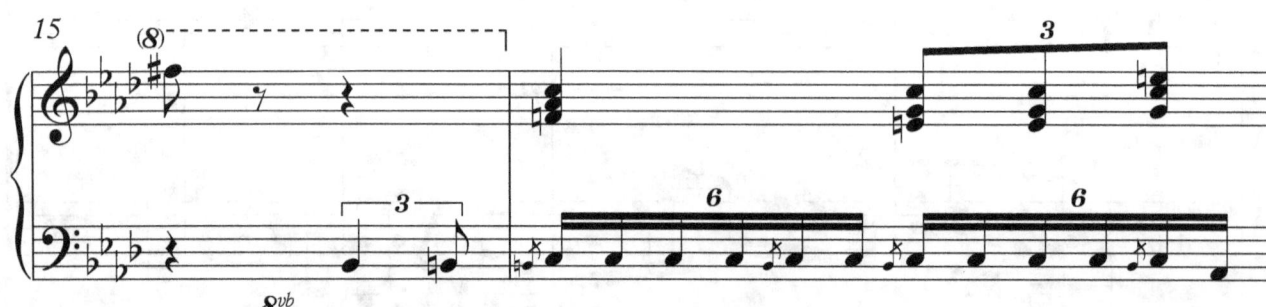

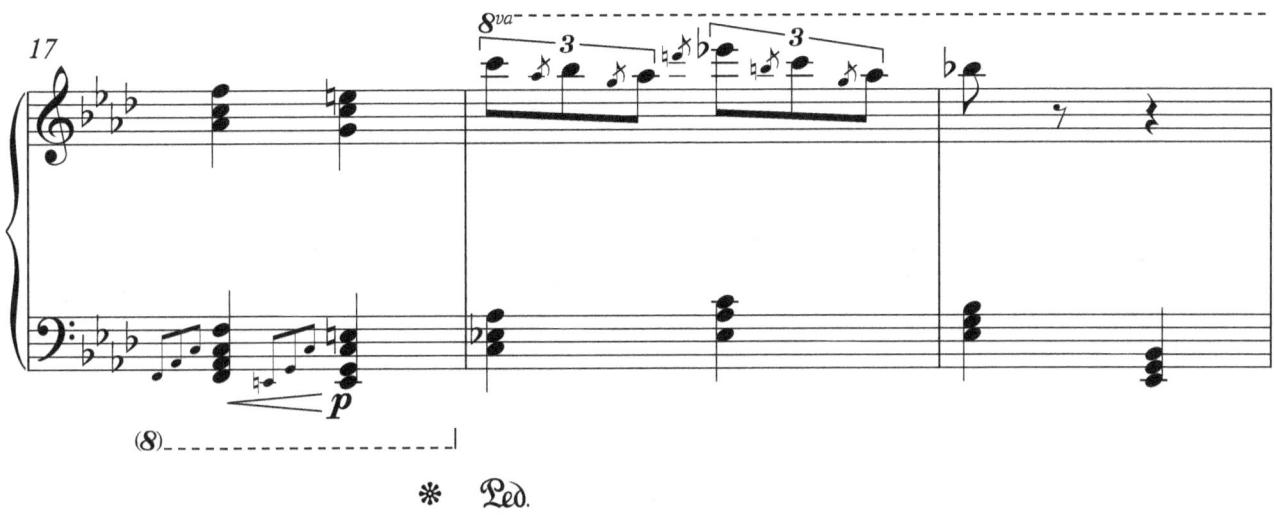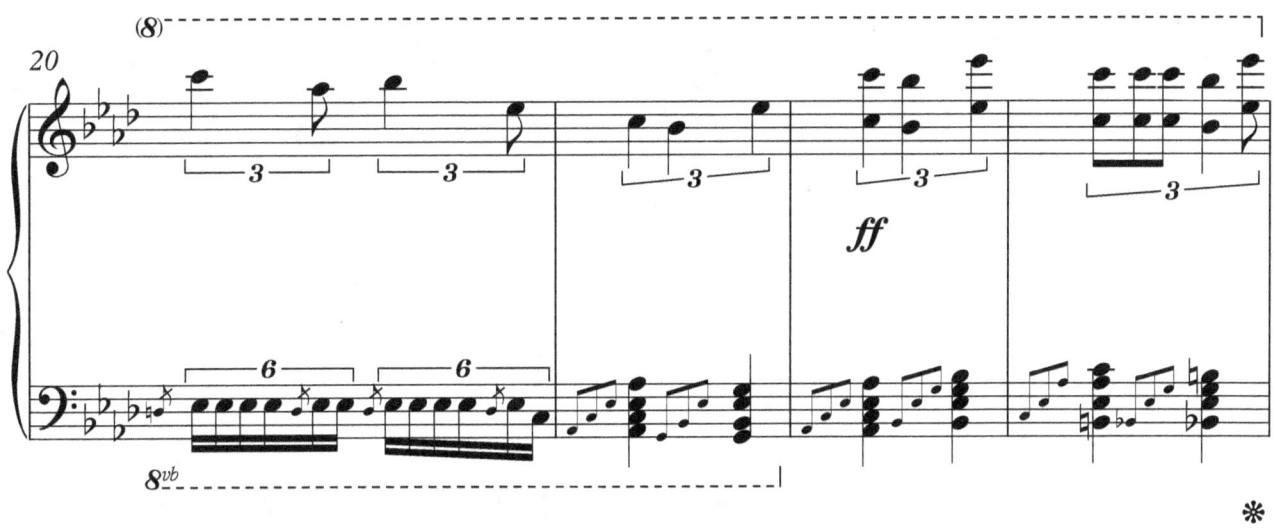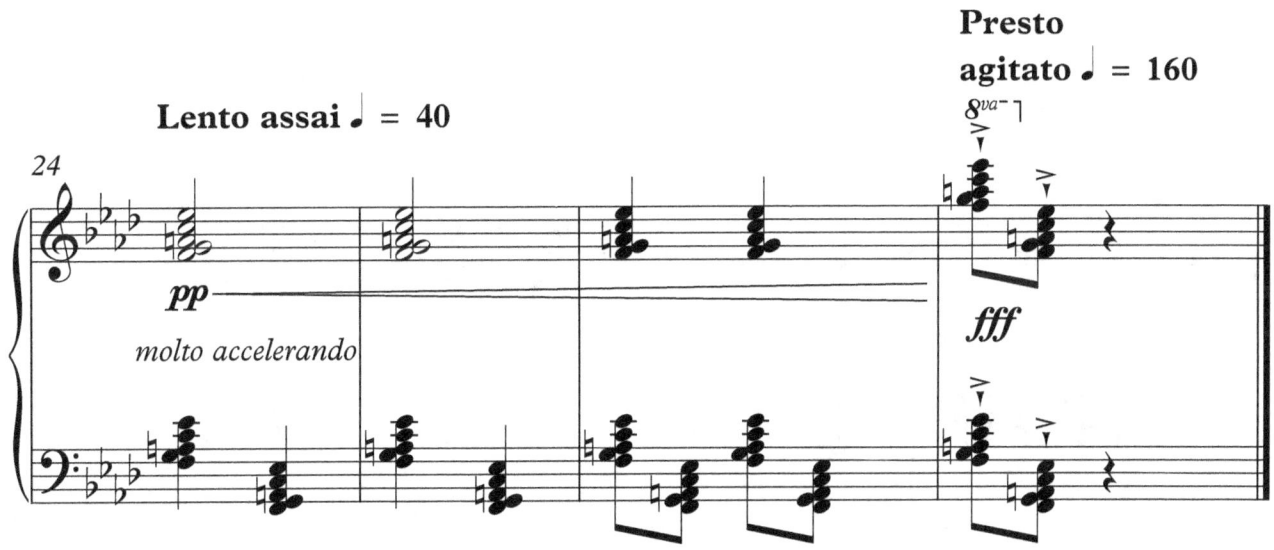

Prelude No. 19
in E-flat major, Op. 2s

Steven O'Brien

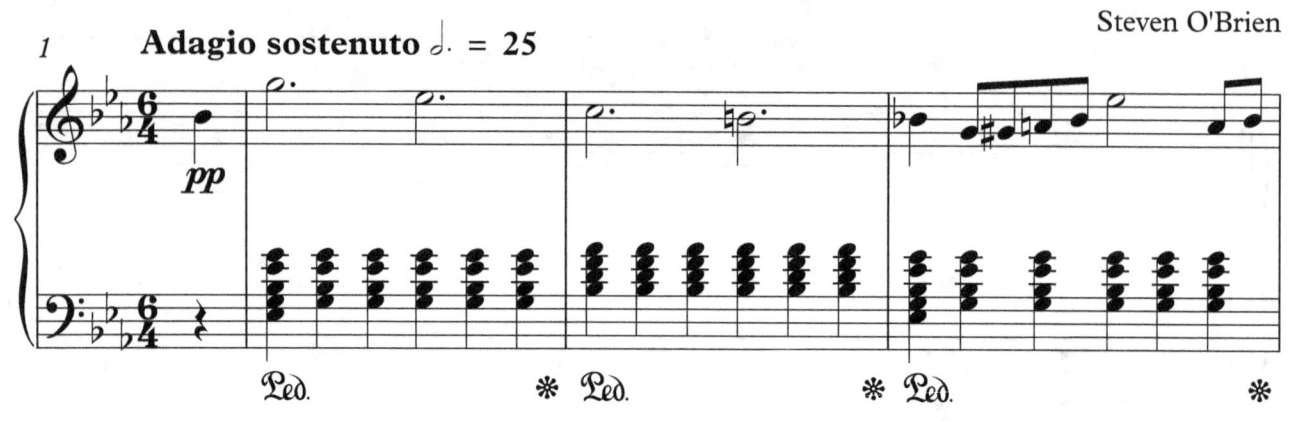
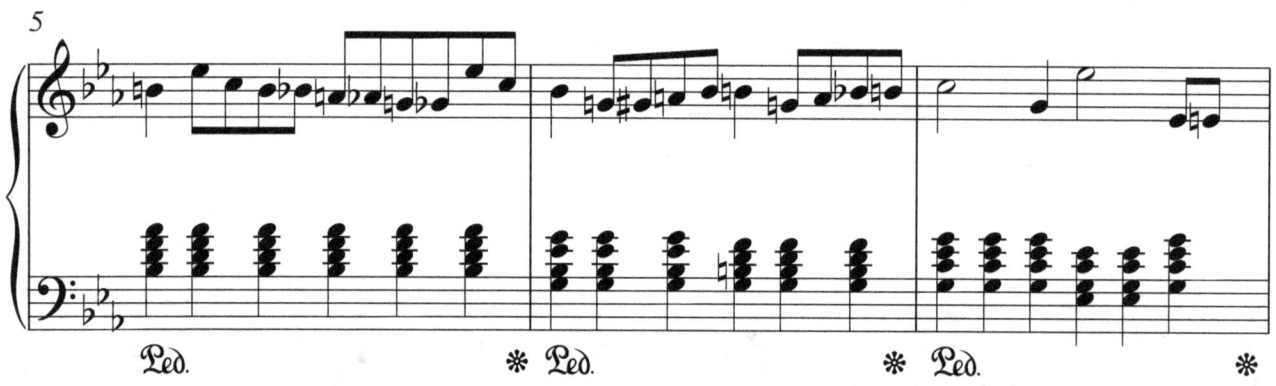
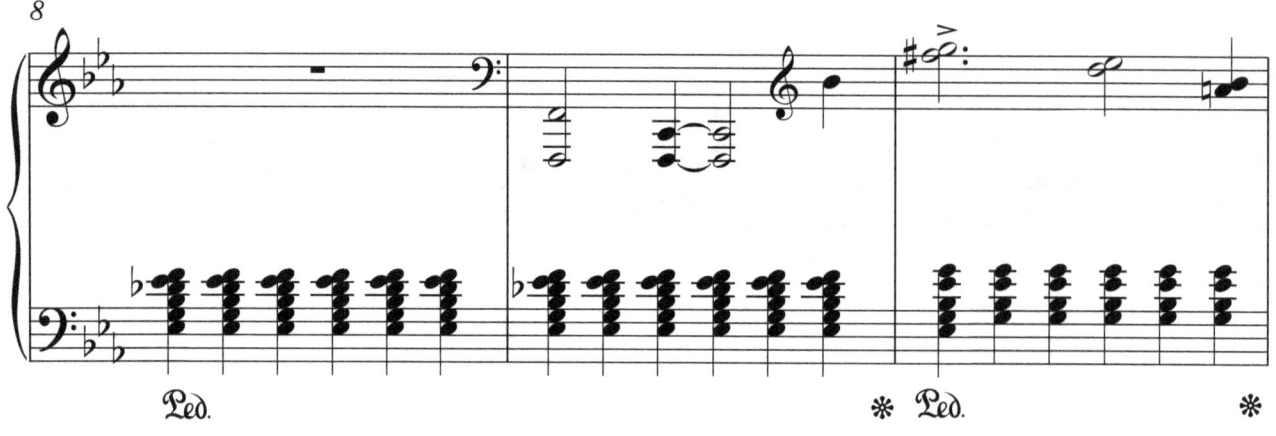
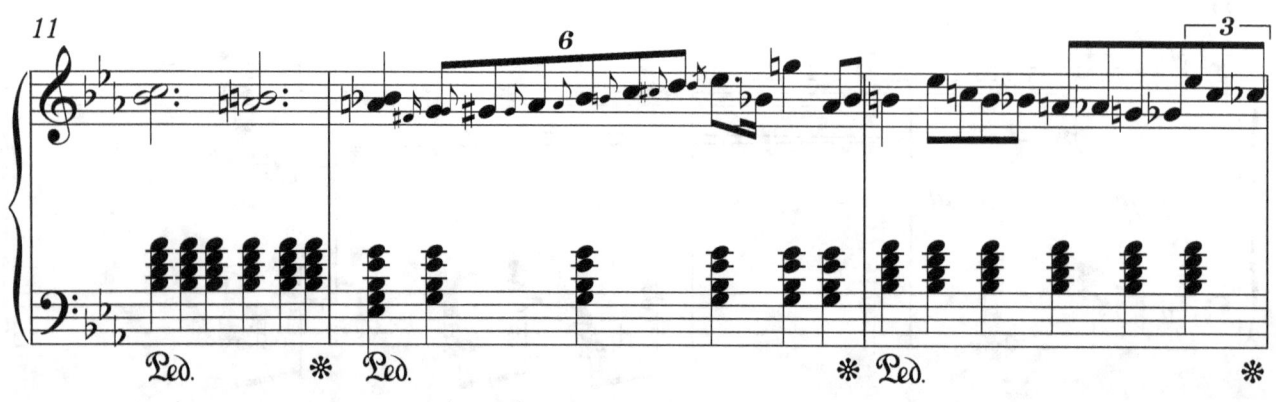

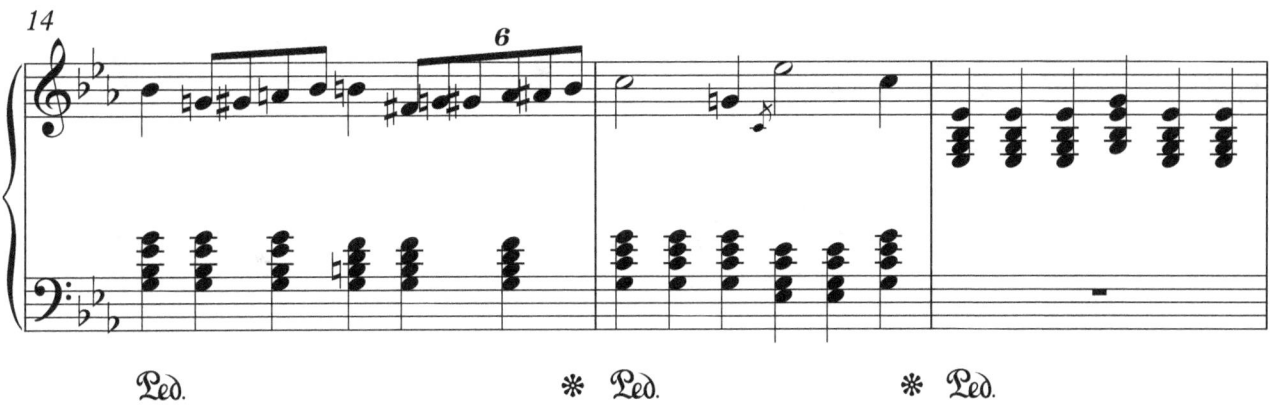
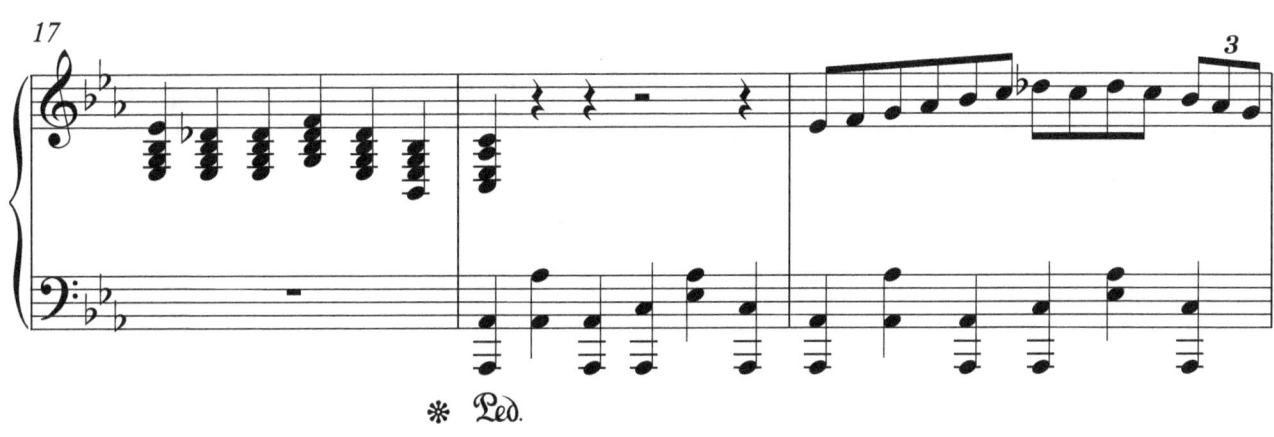
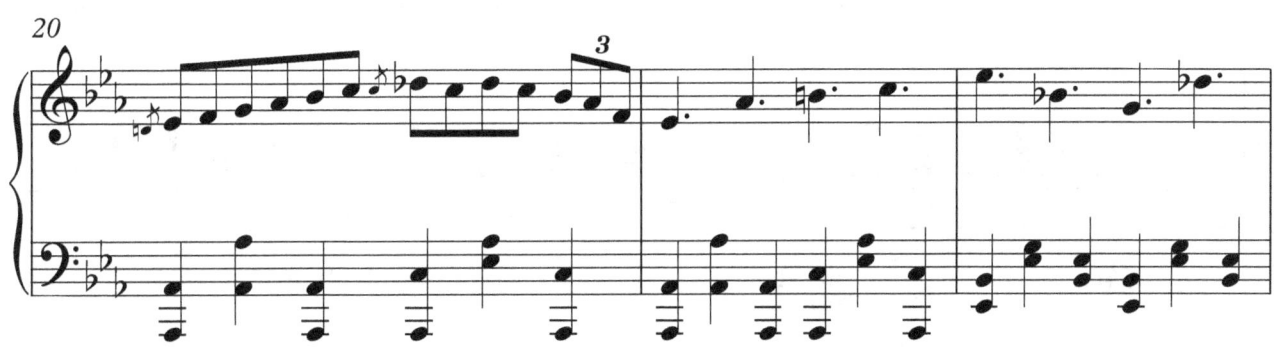
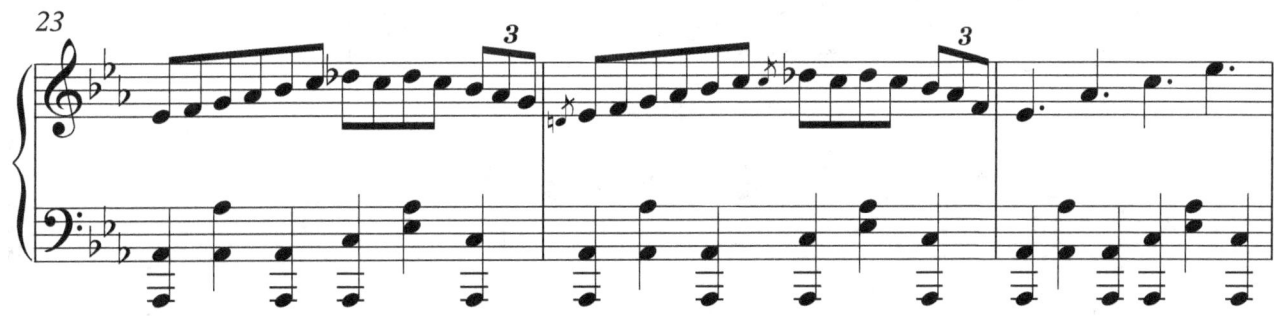

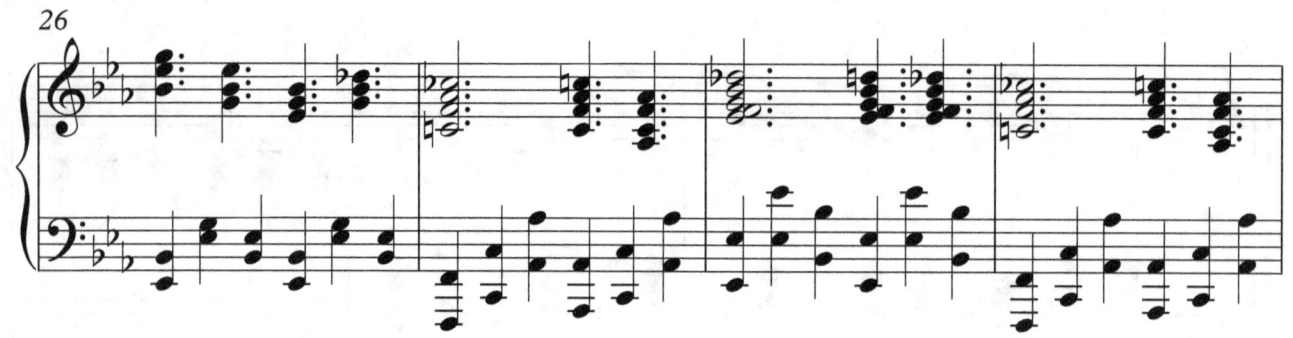
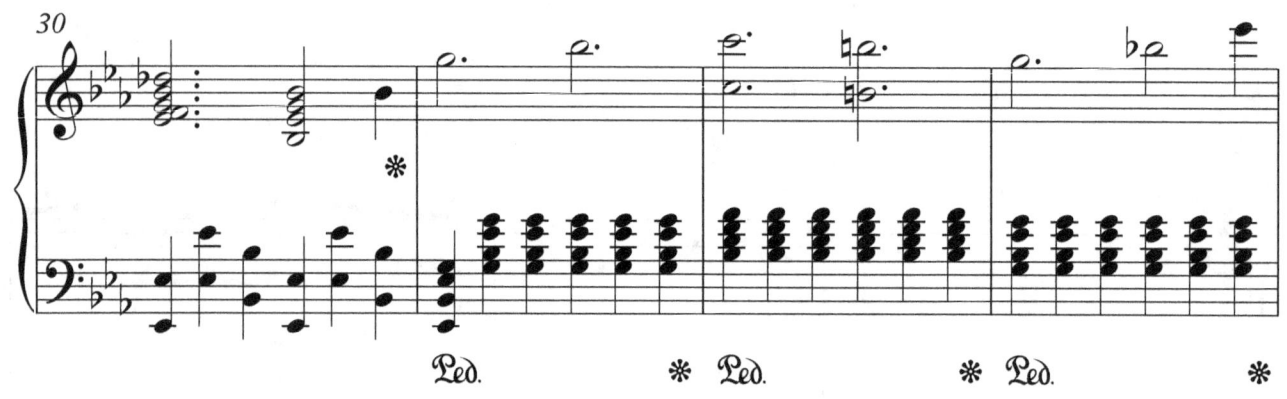
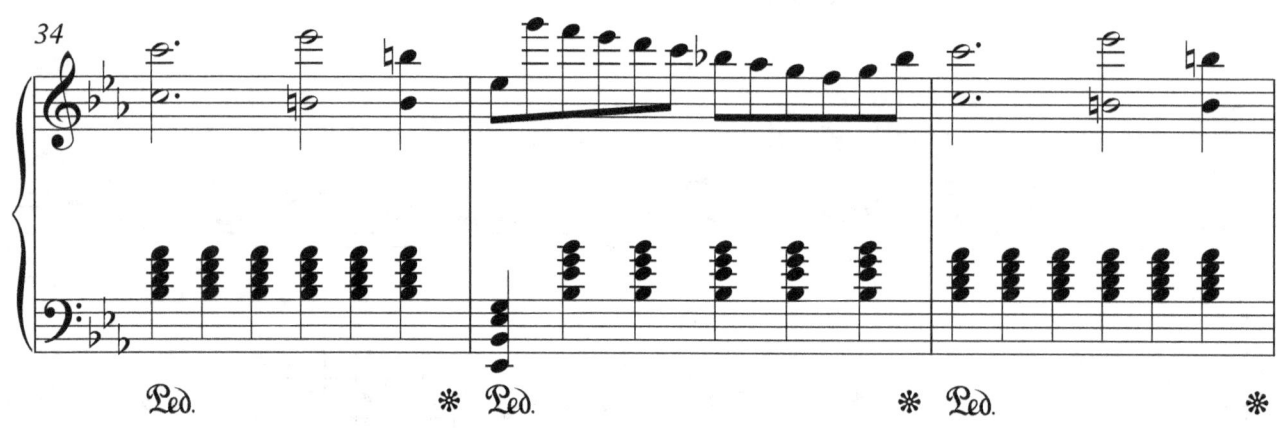
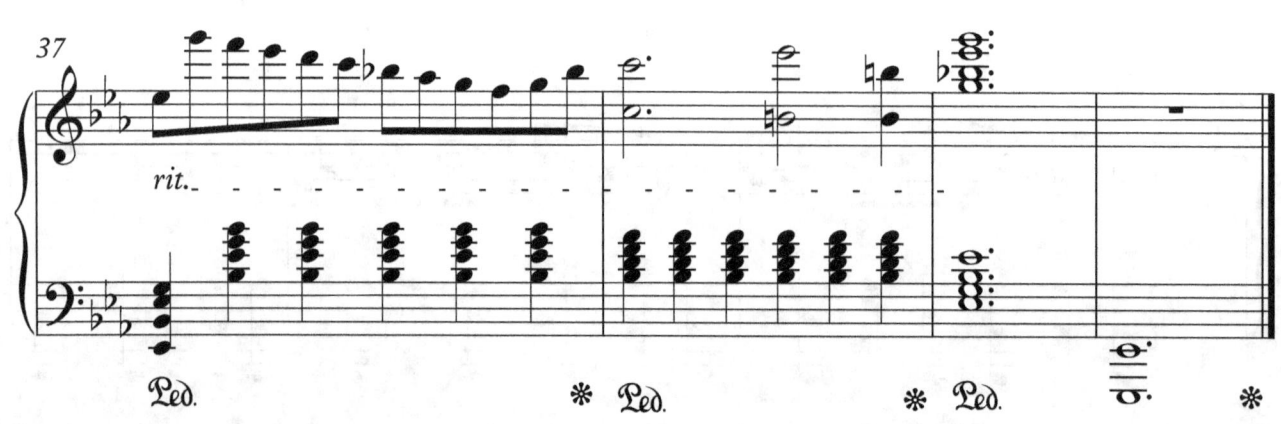

Prelude No. 20
in C minor, Op. 2t

Steven O'Brien

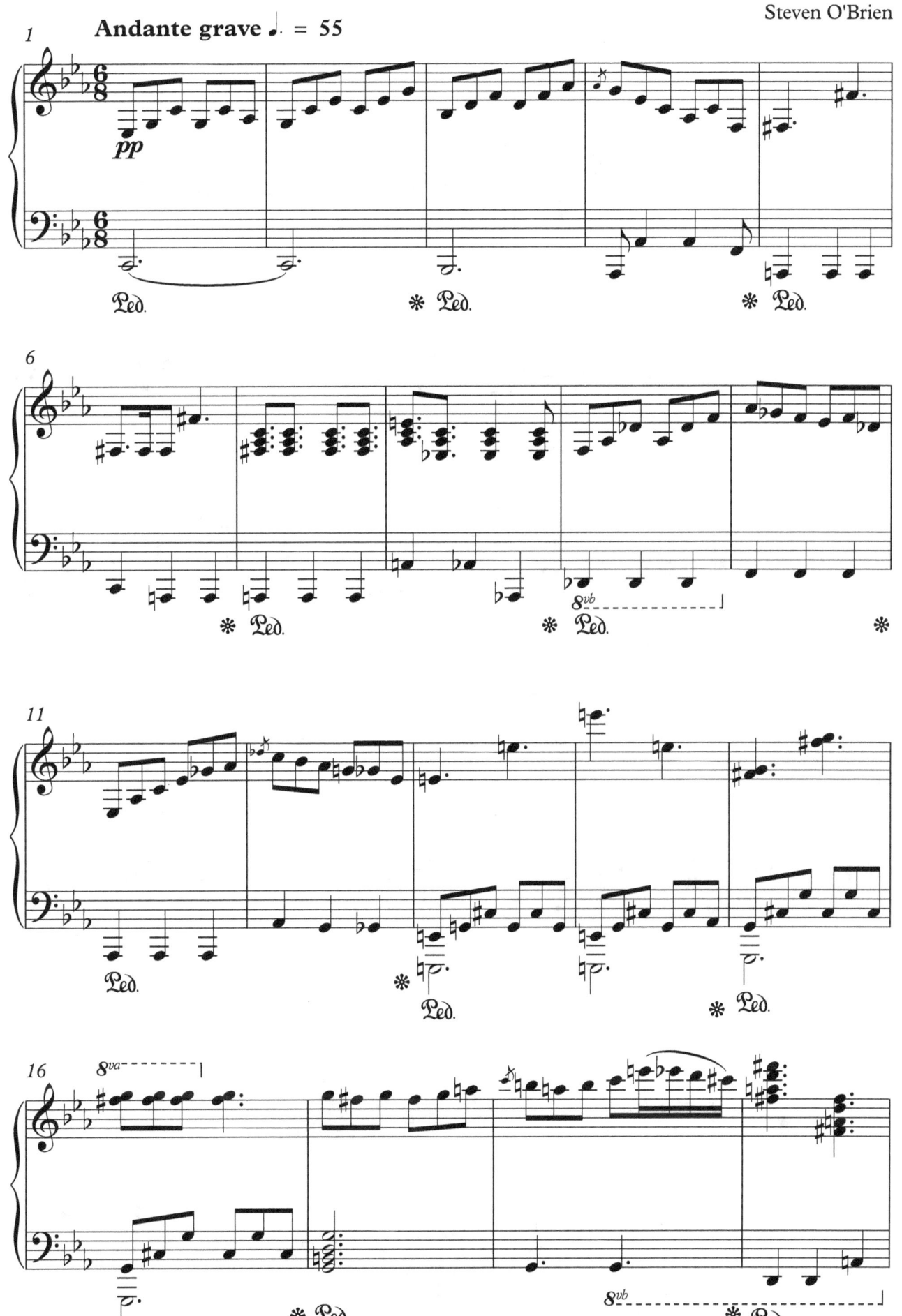

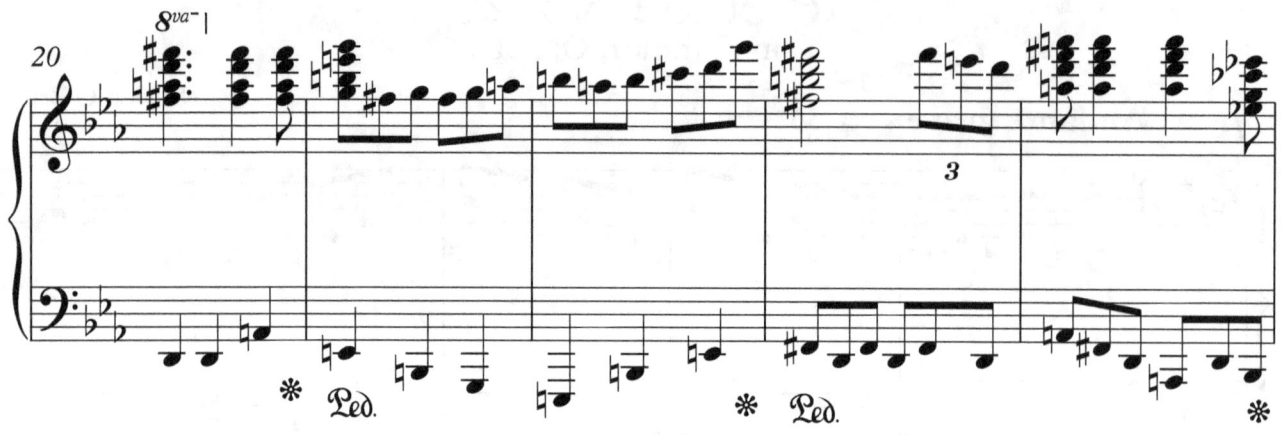
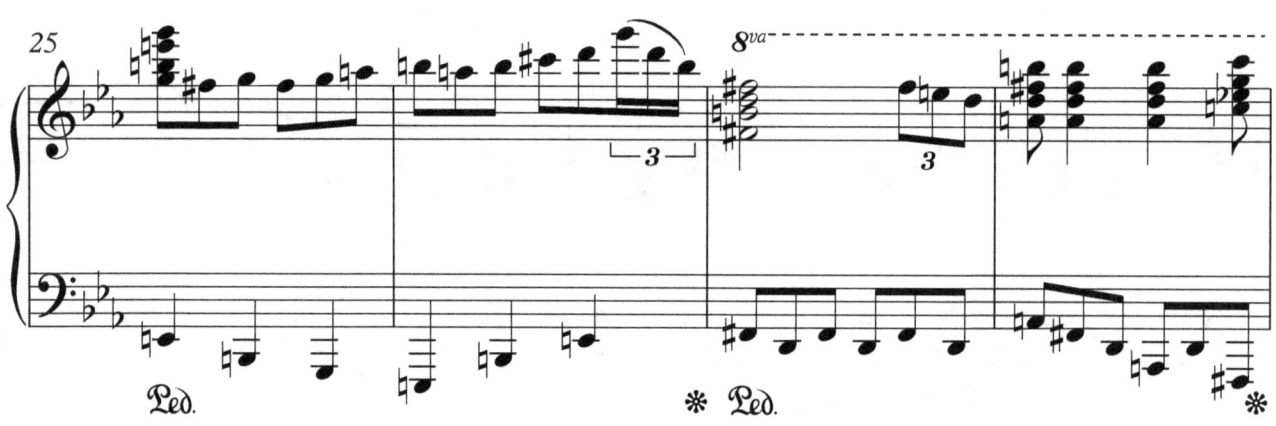
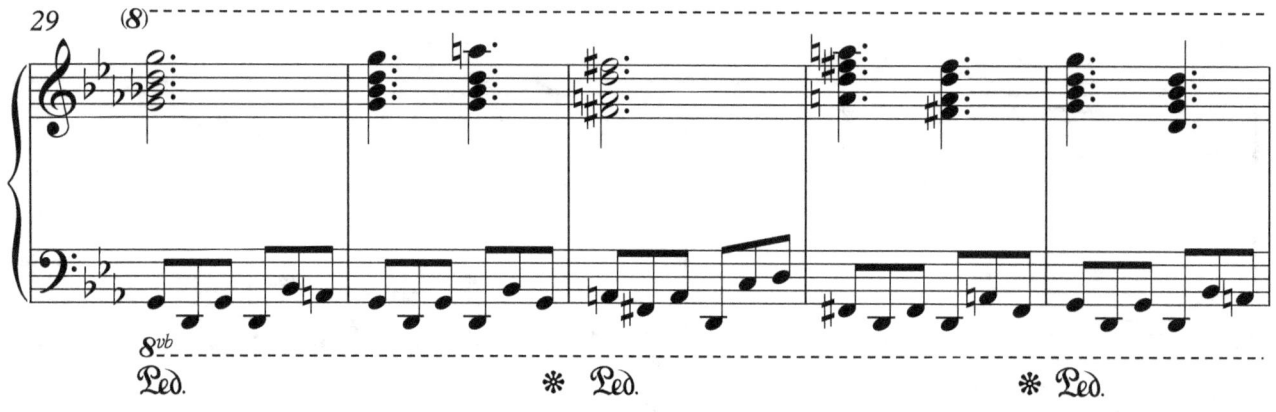
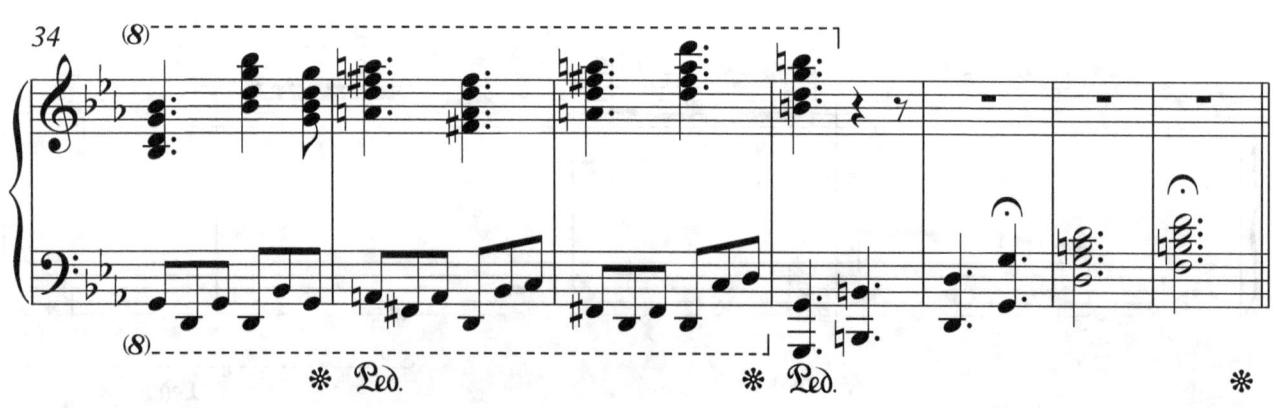

50

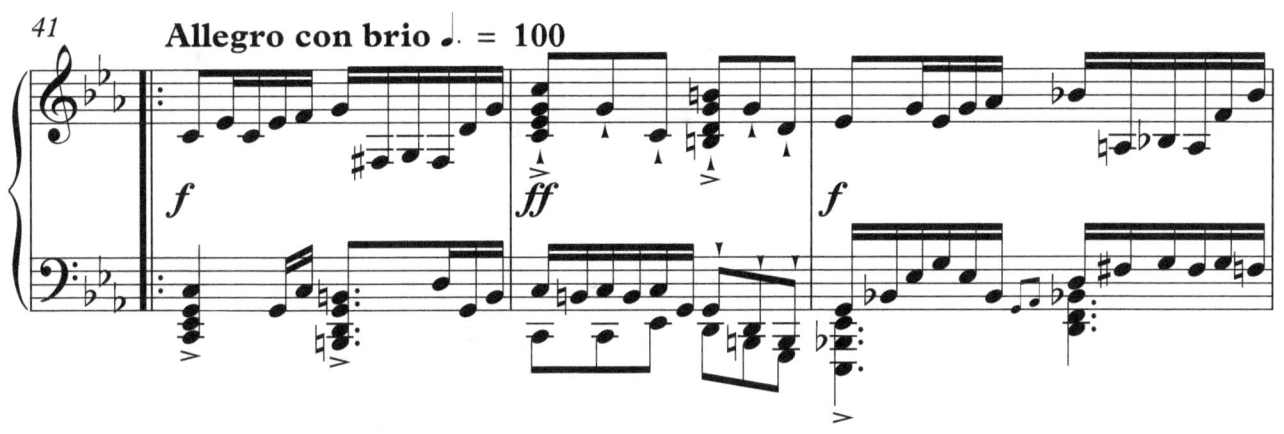

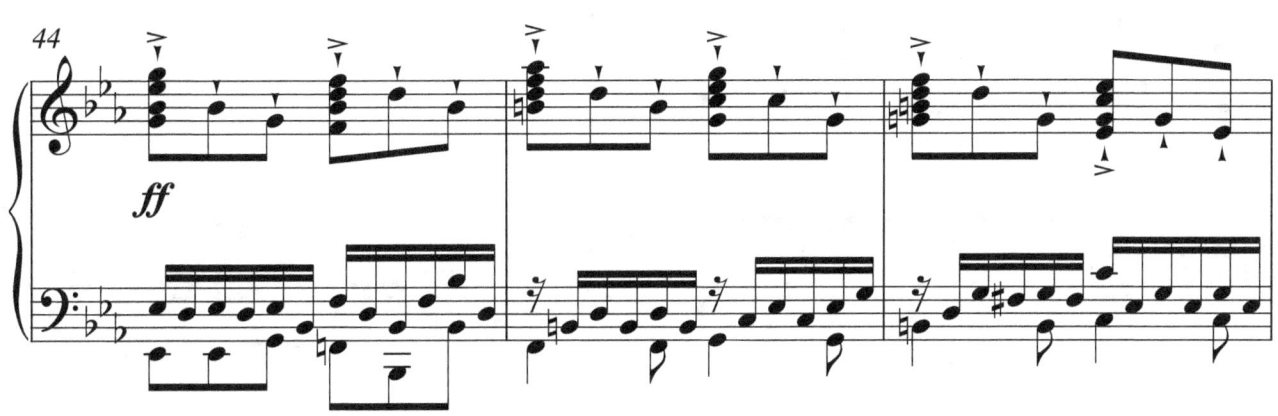

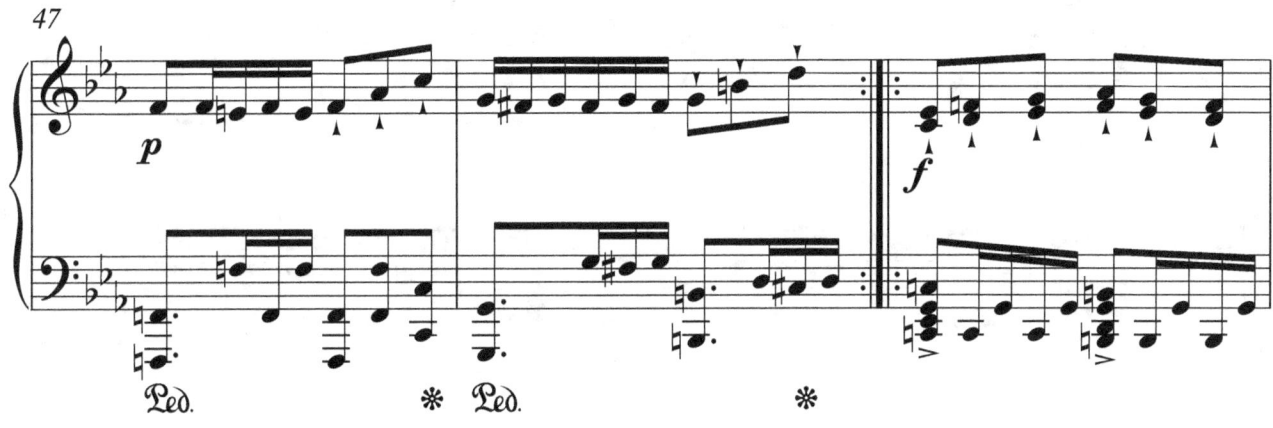

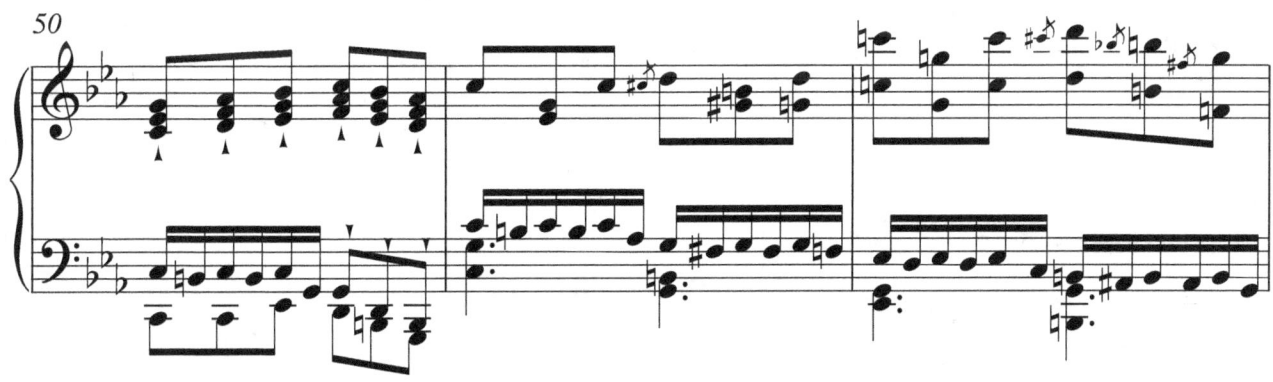

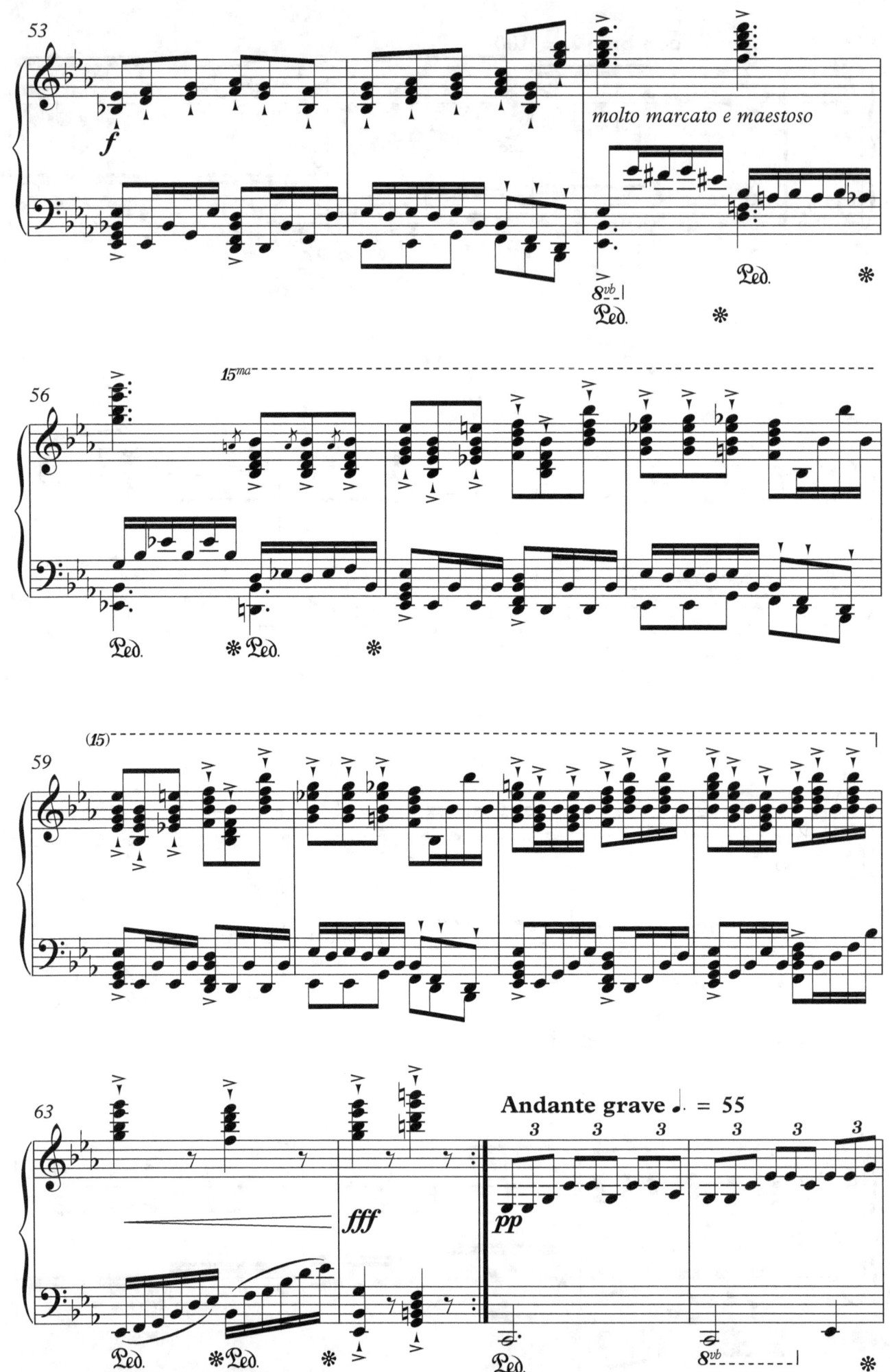

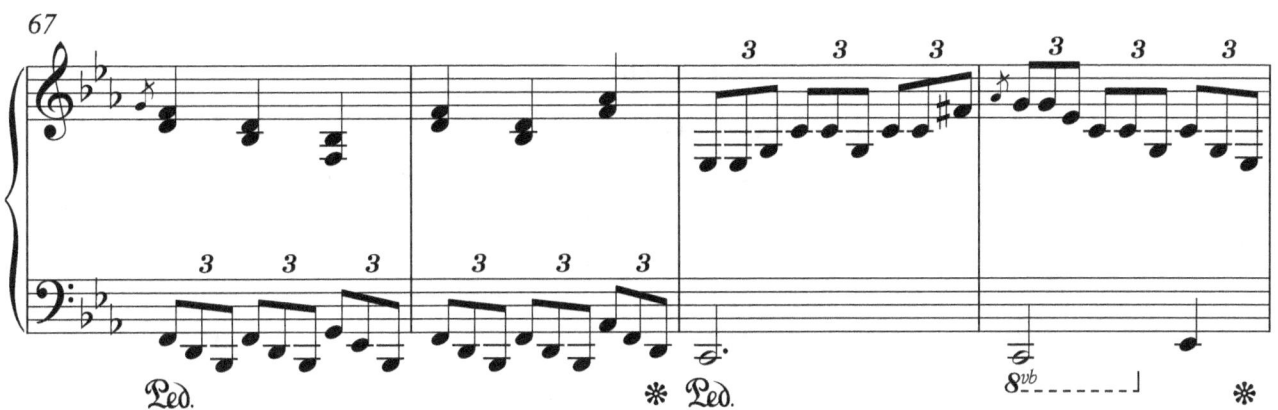
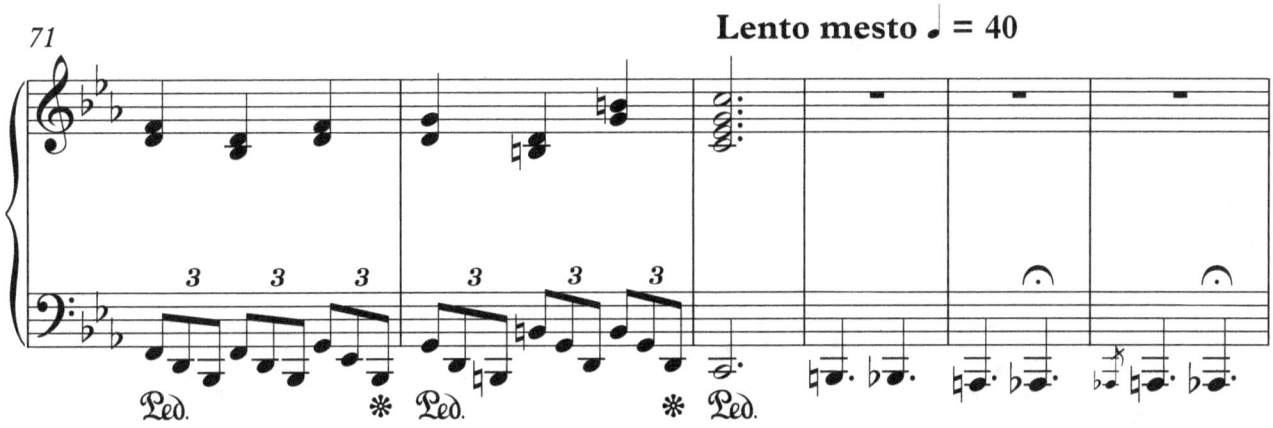
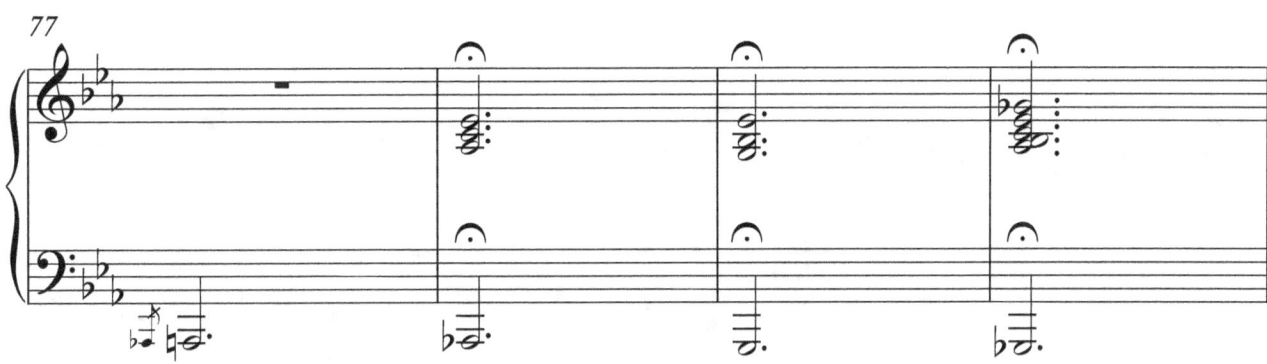
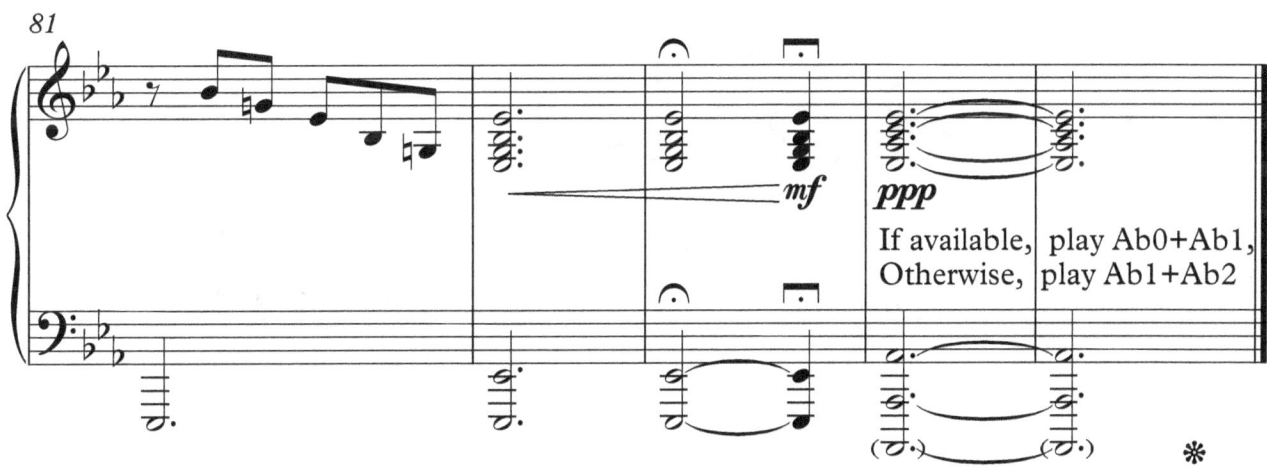

Prelude No. 21
in B-flat major, Op. 2u

Steven O'Brien

Largo appassionato e cantabile ♩. = 25

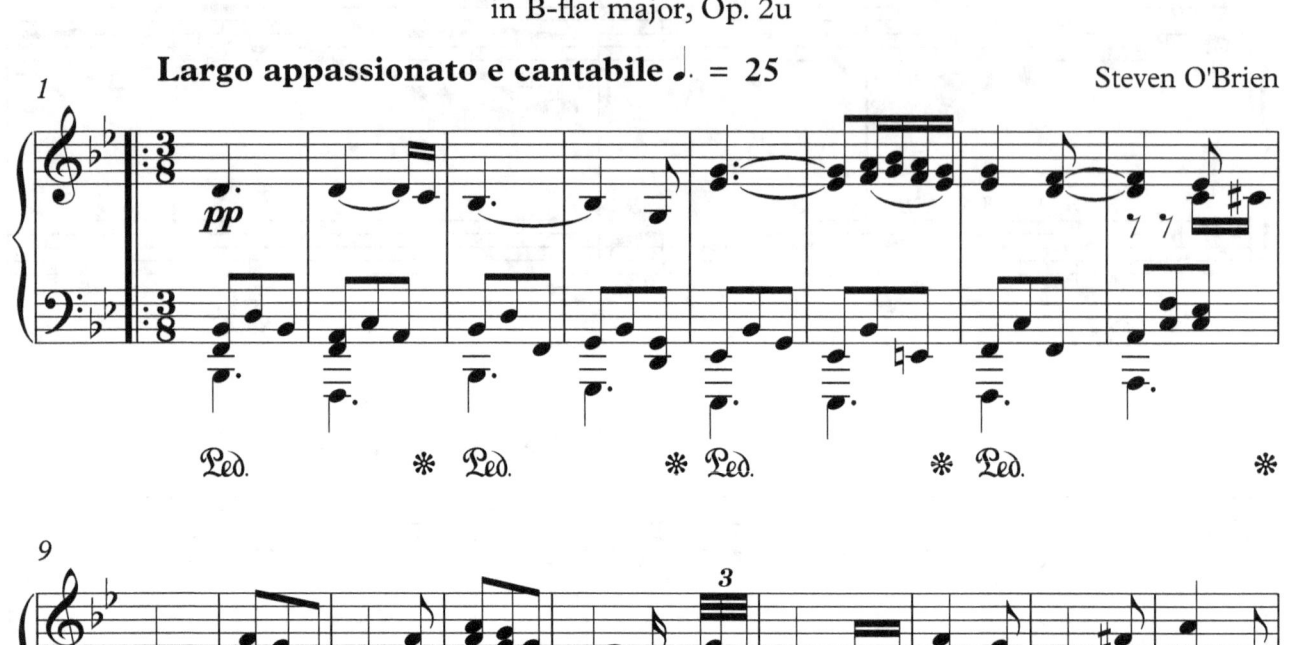
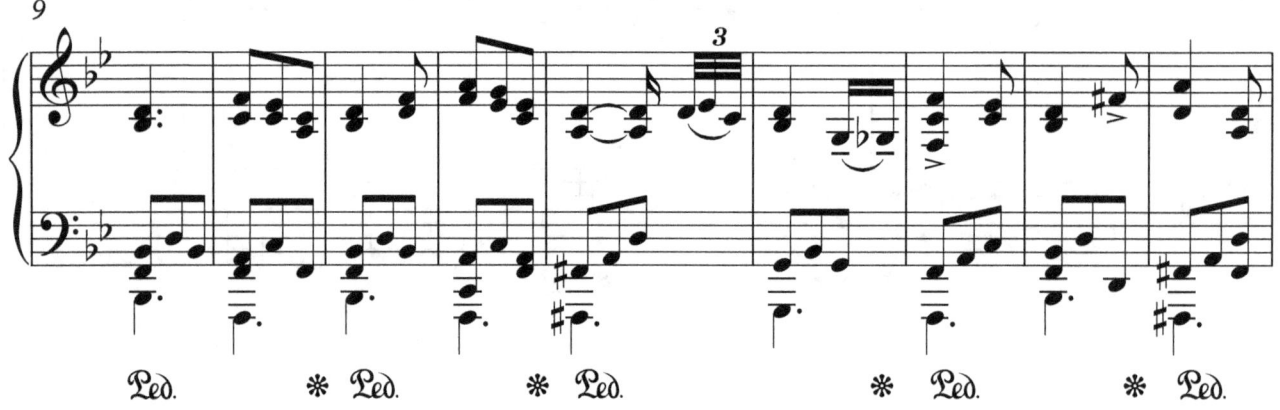
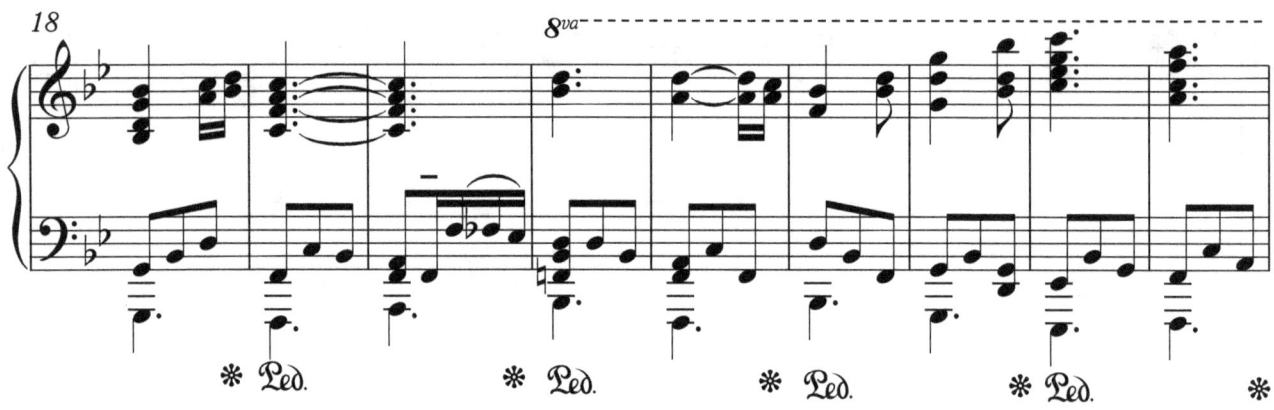
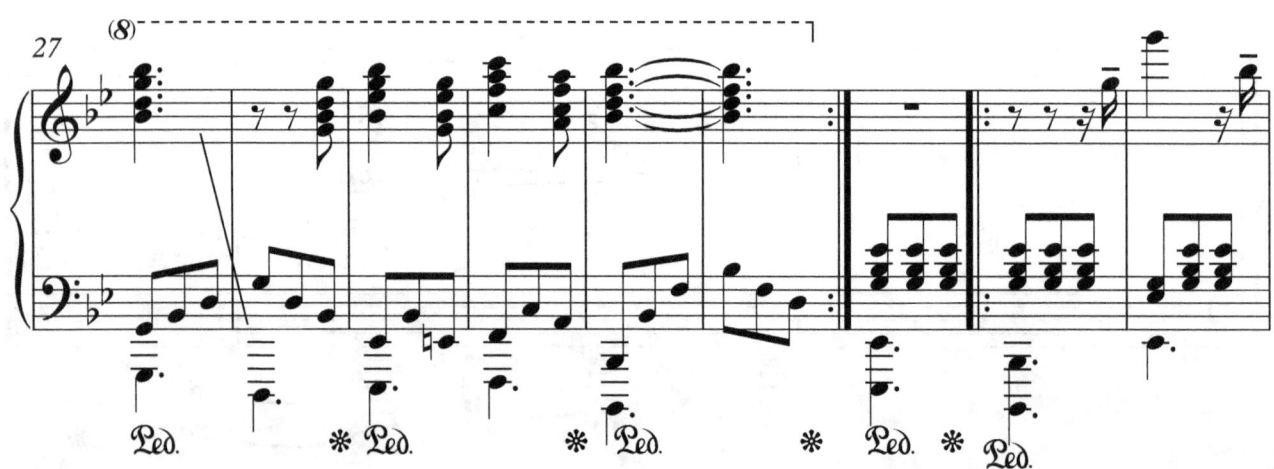

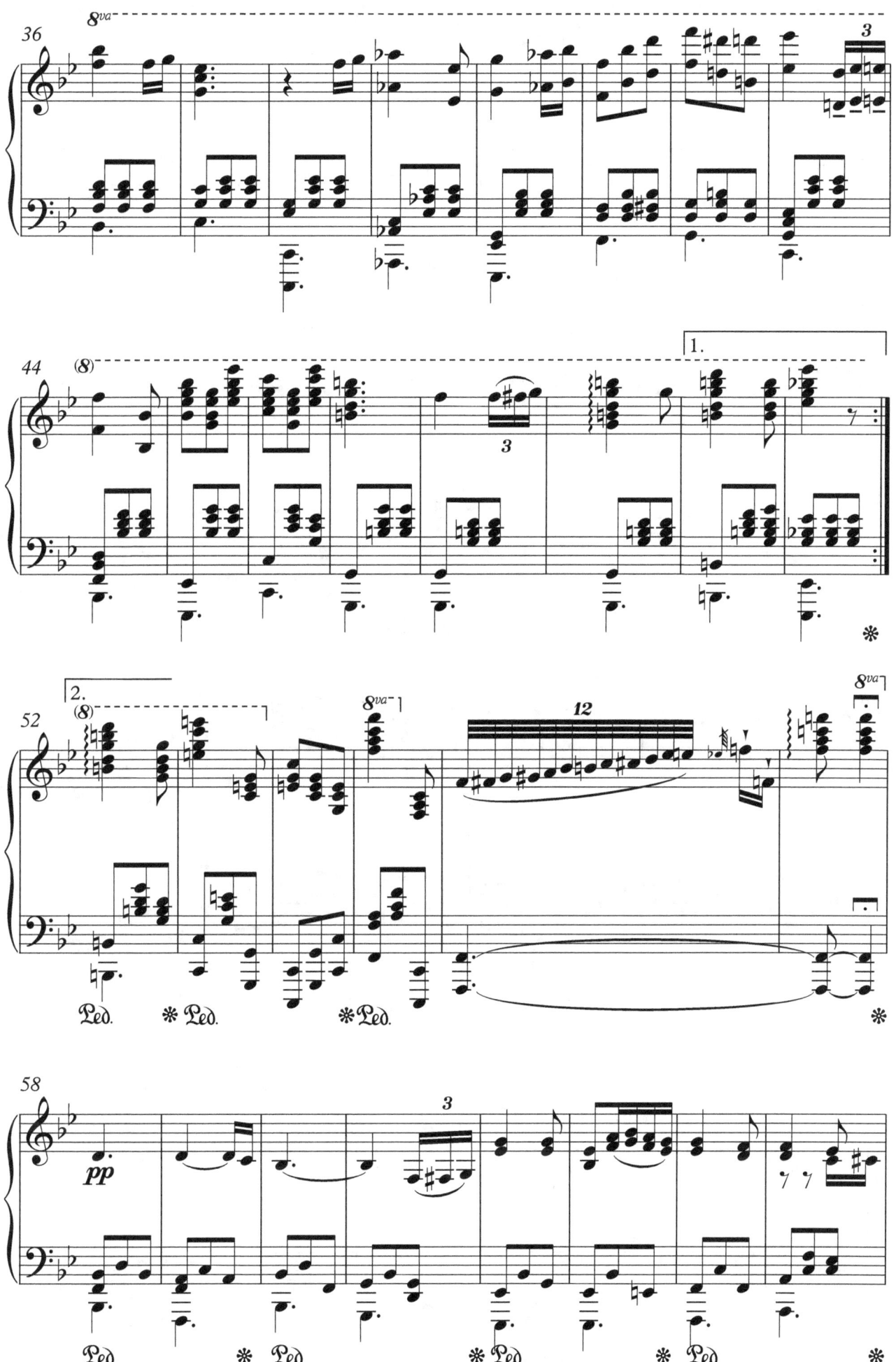

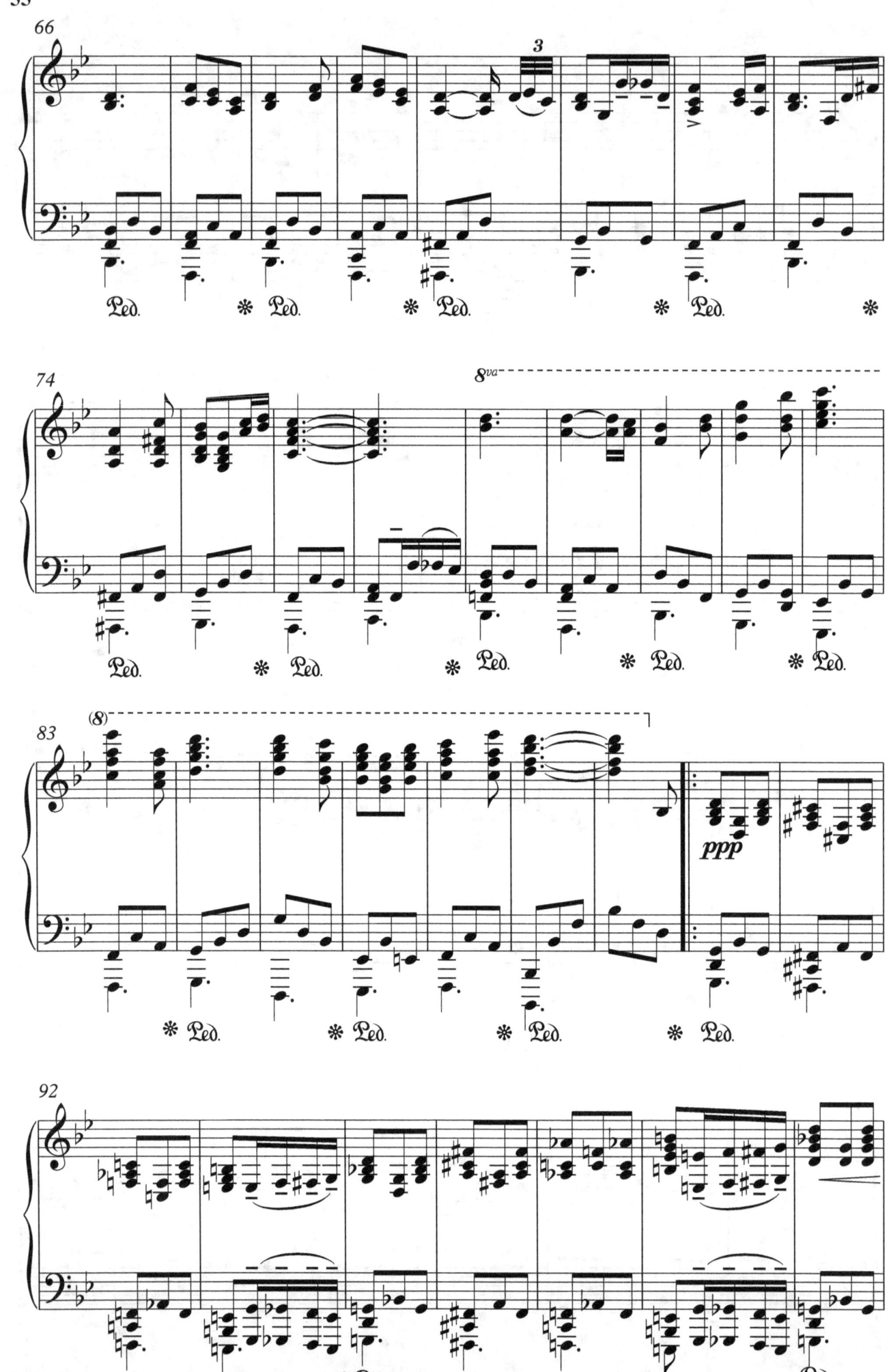

Prelude No. 22
in G minor, Op. 2v

Steven O'Brien

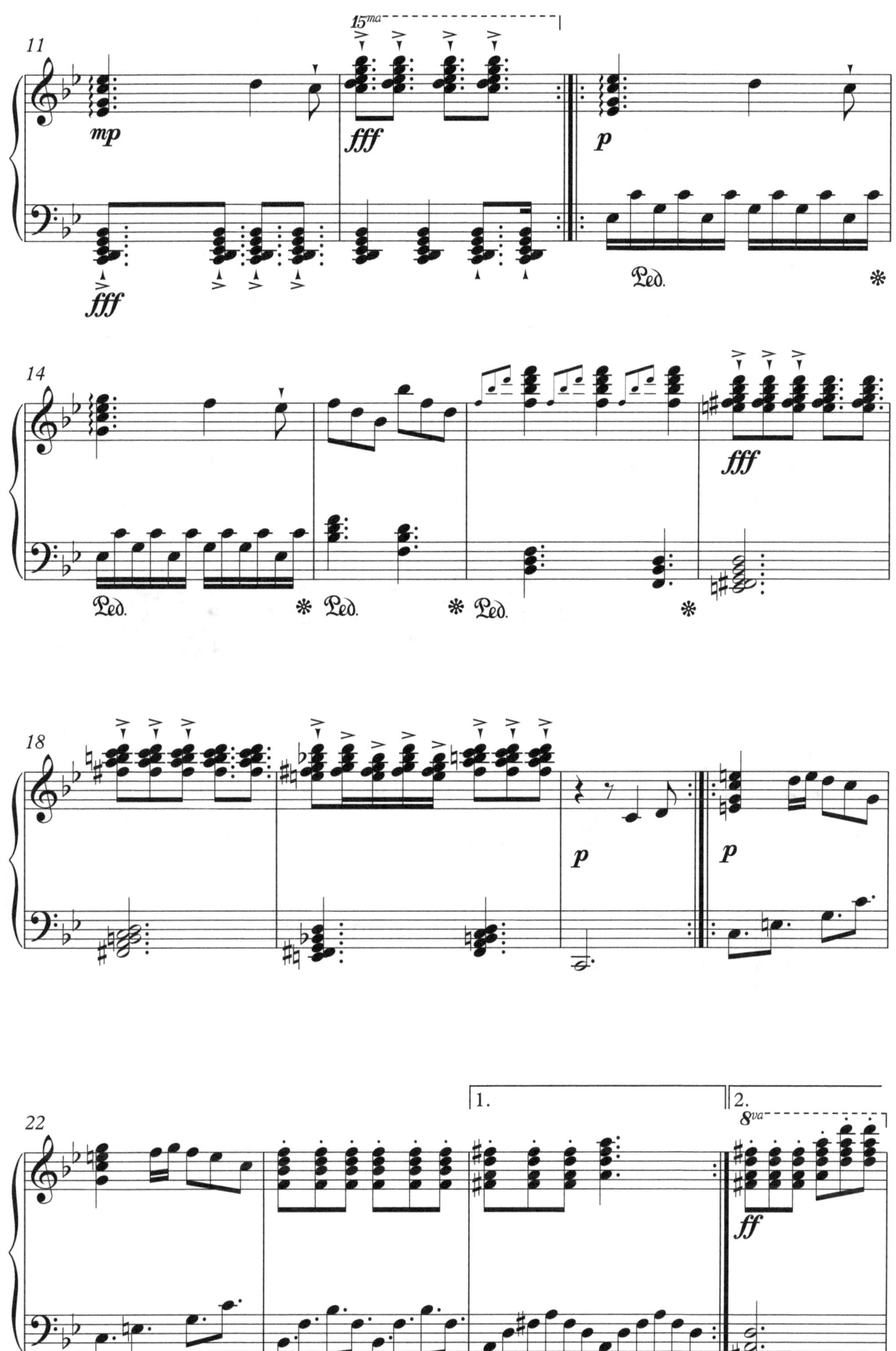

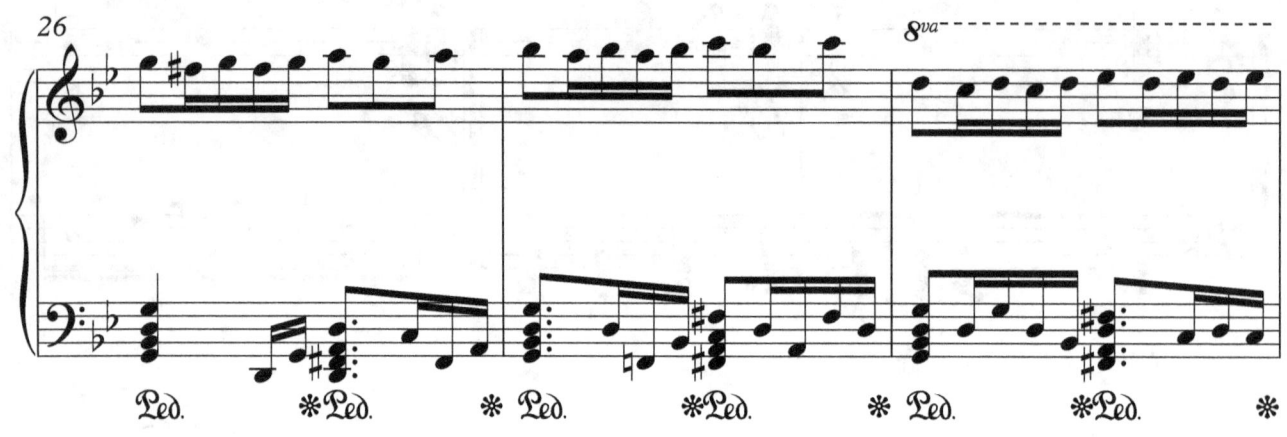
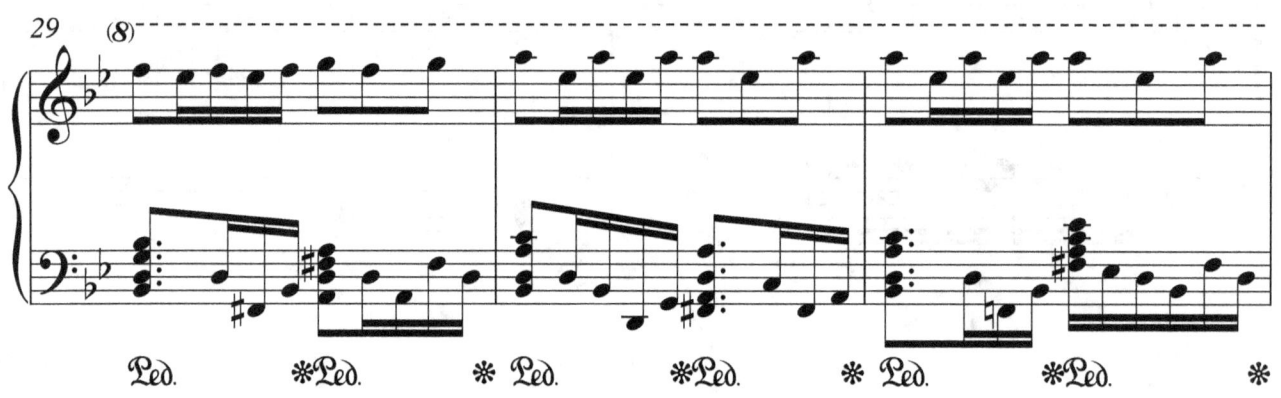
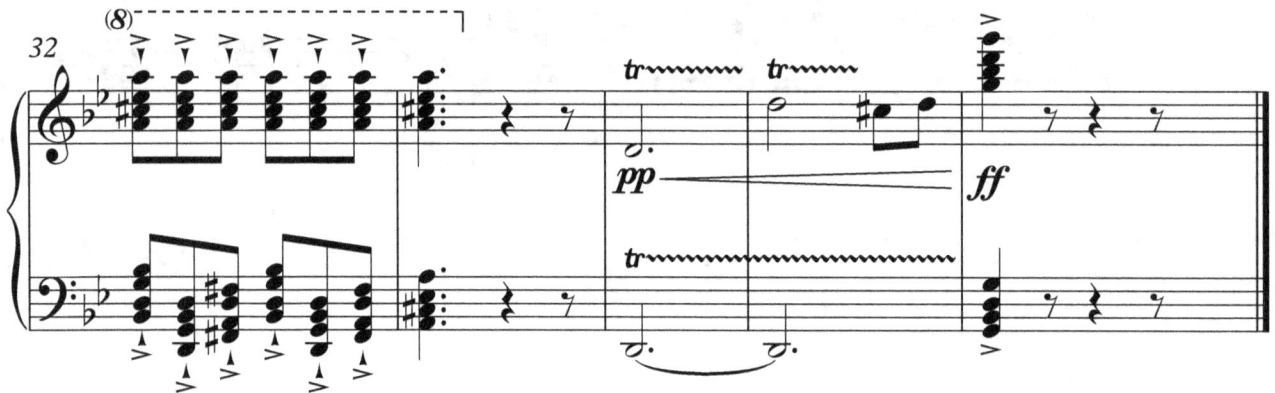

Prelude No. 23
in F major, Op. 2w

Steven O'Brien

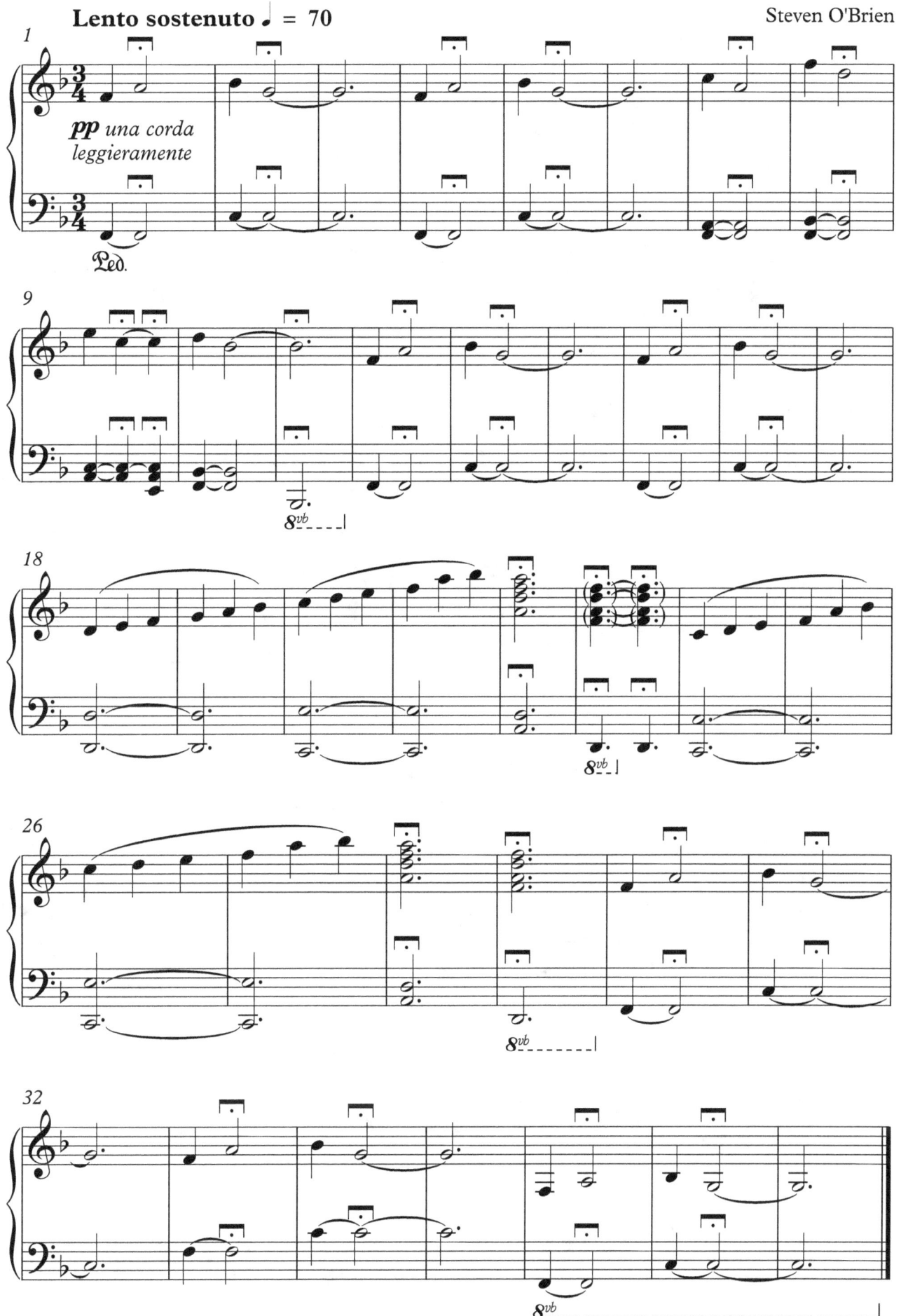

Prelude No. 24
in D minor, Op. 2x

Steven O'Brien

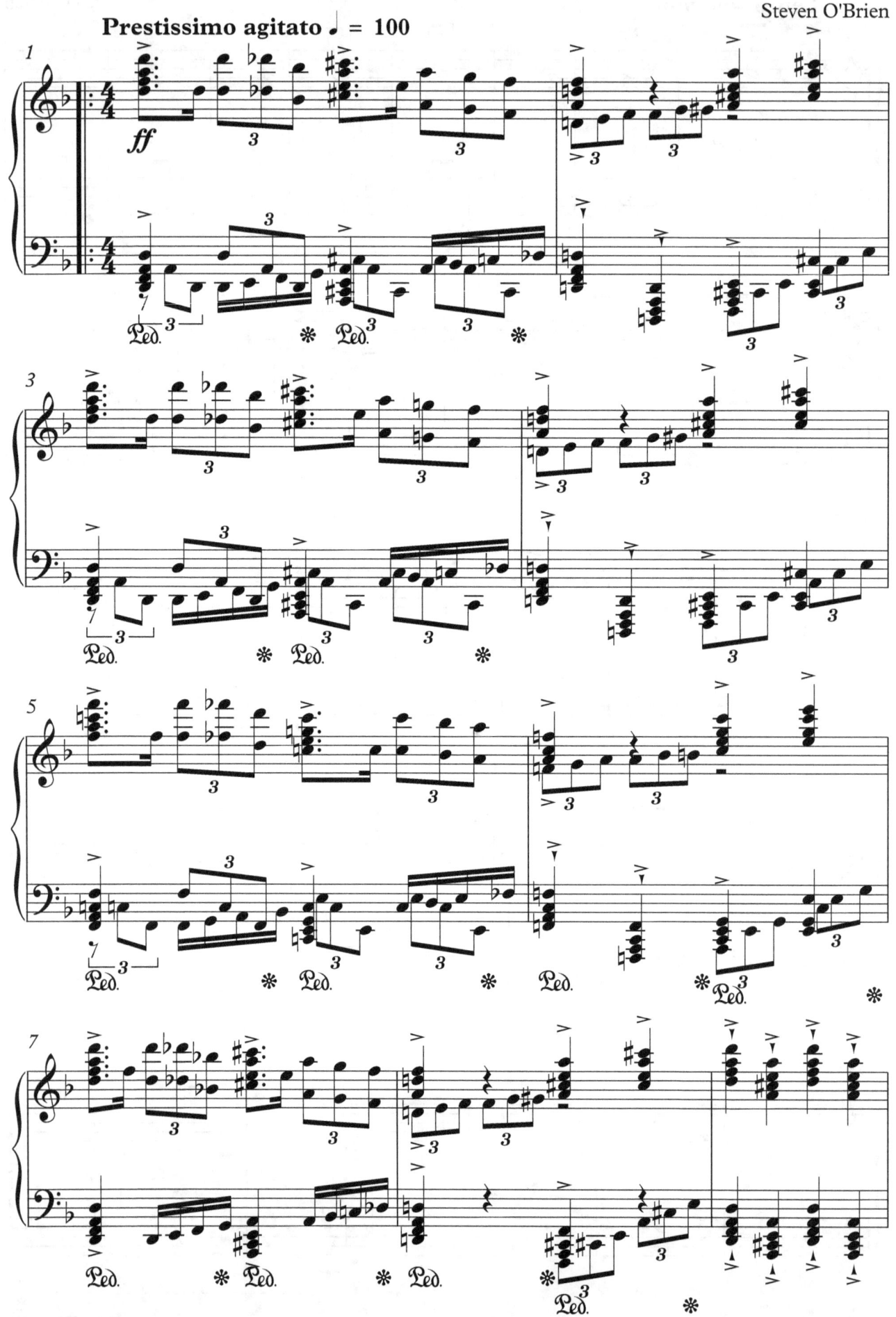

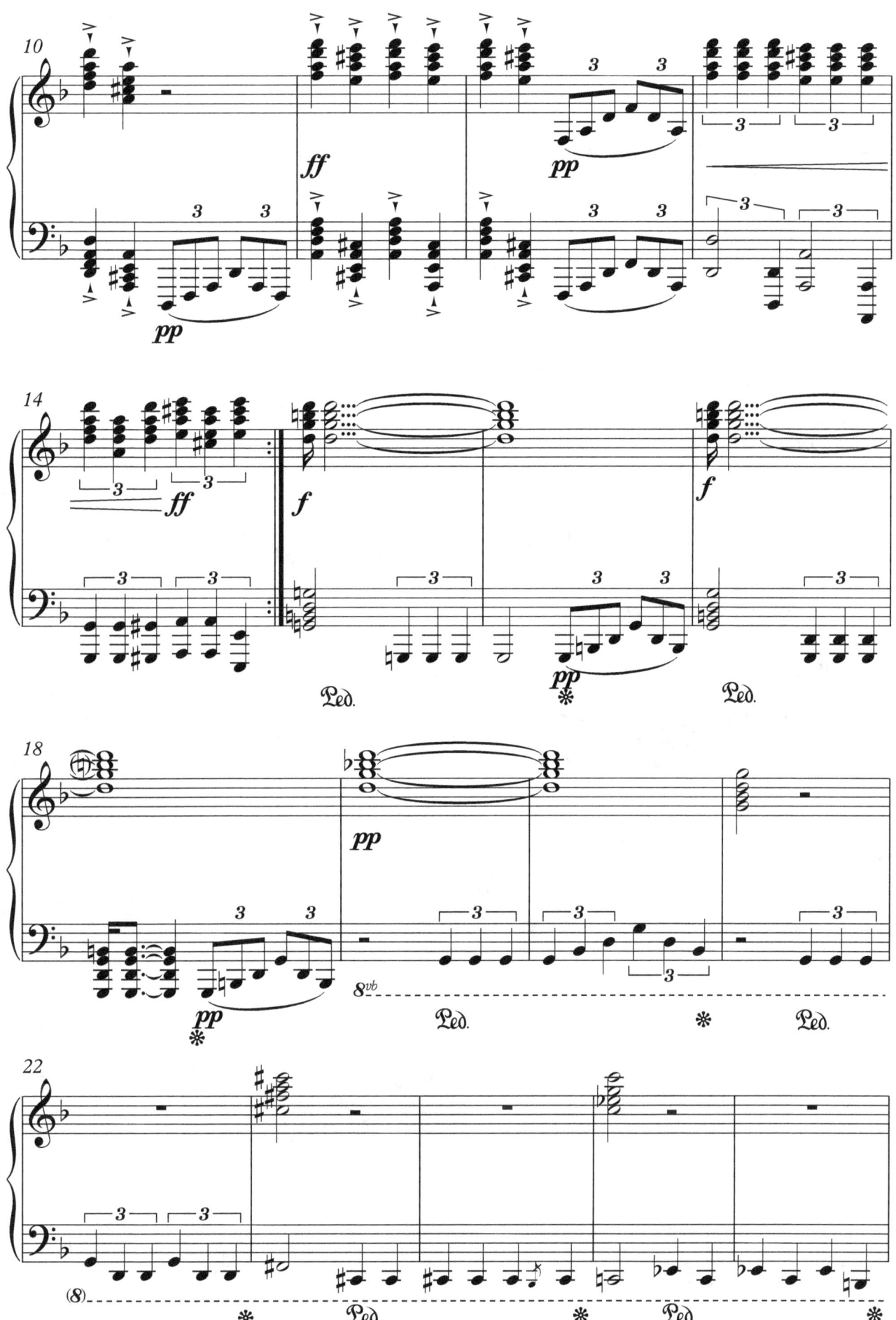

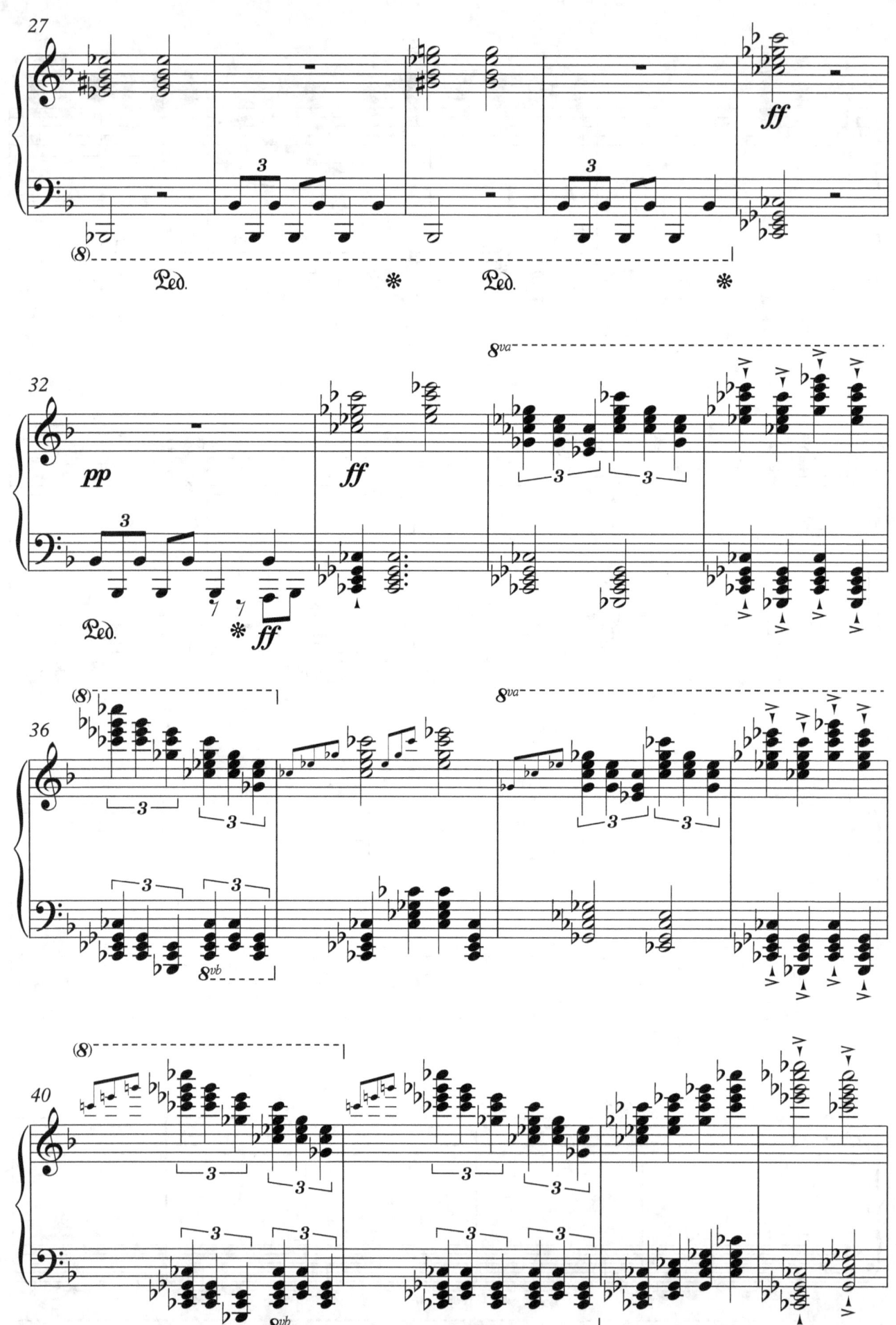

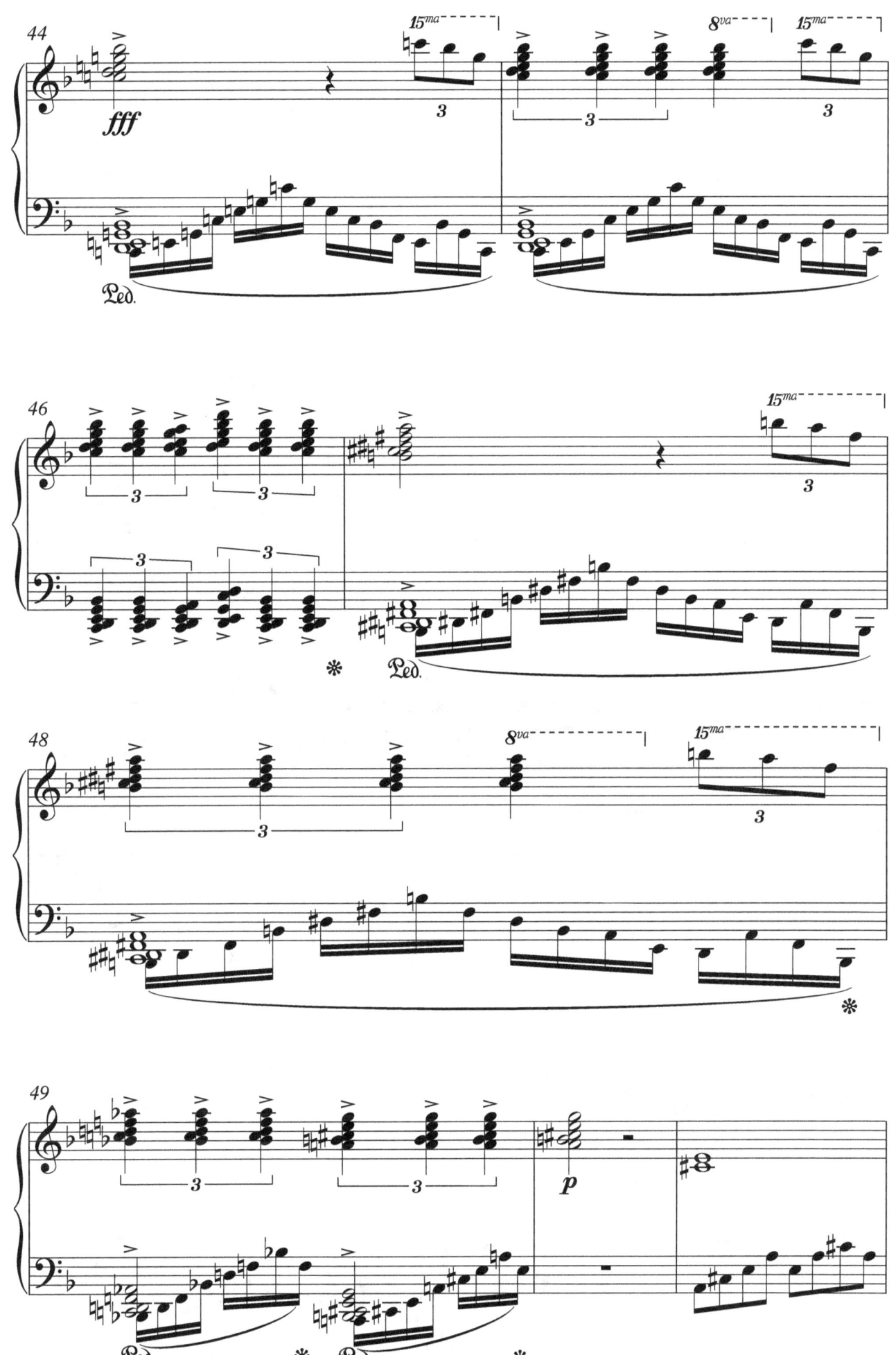

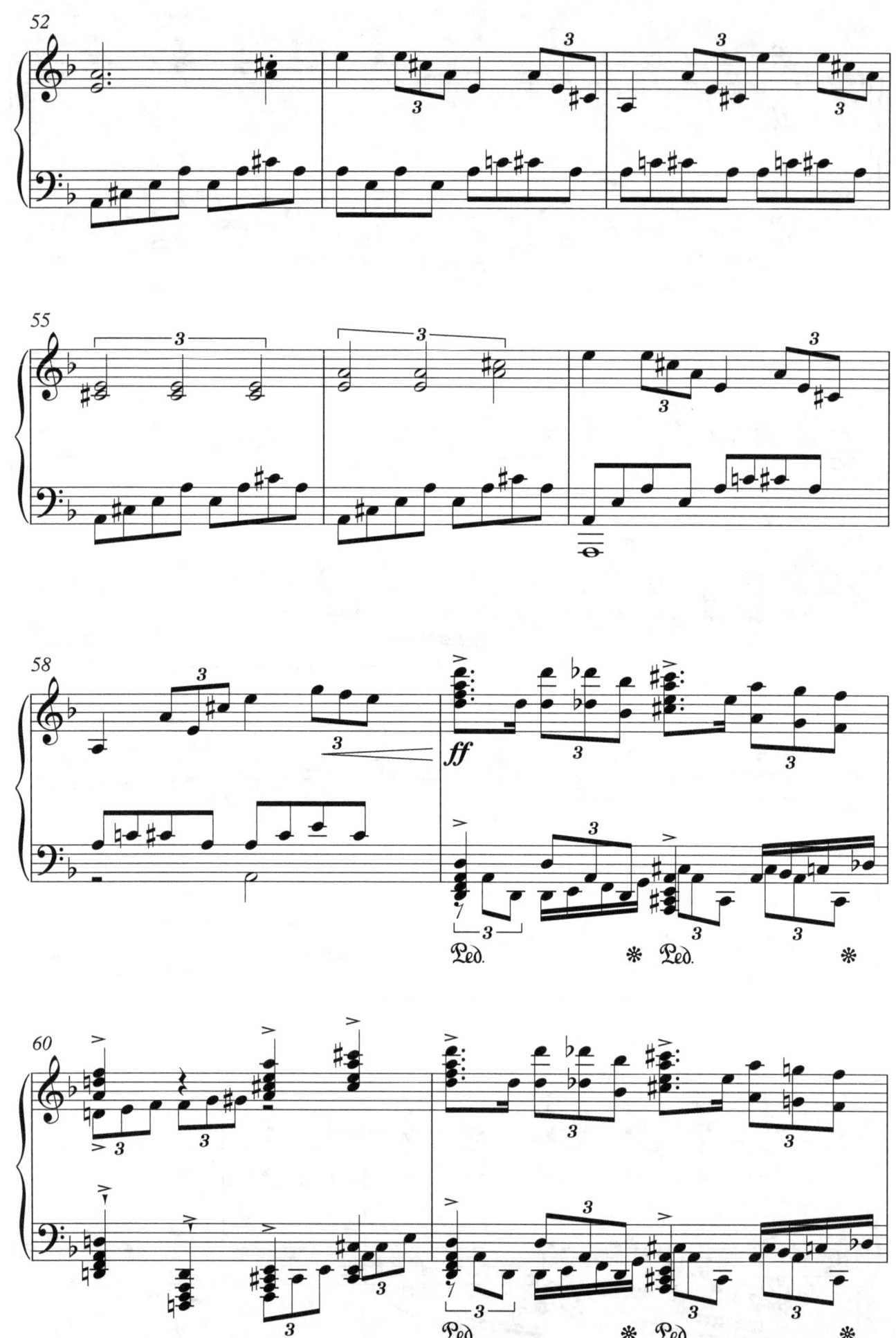

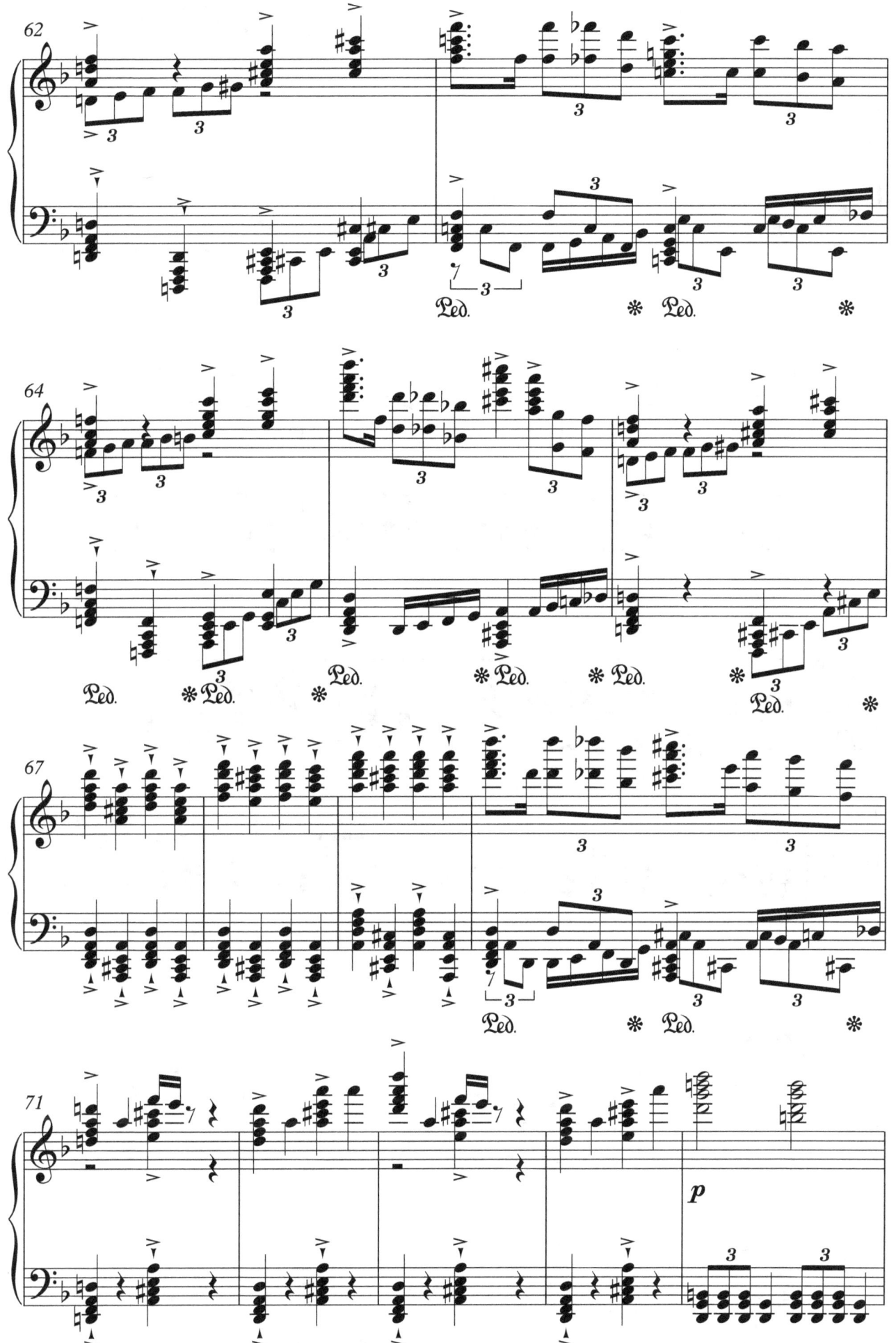

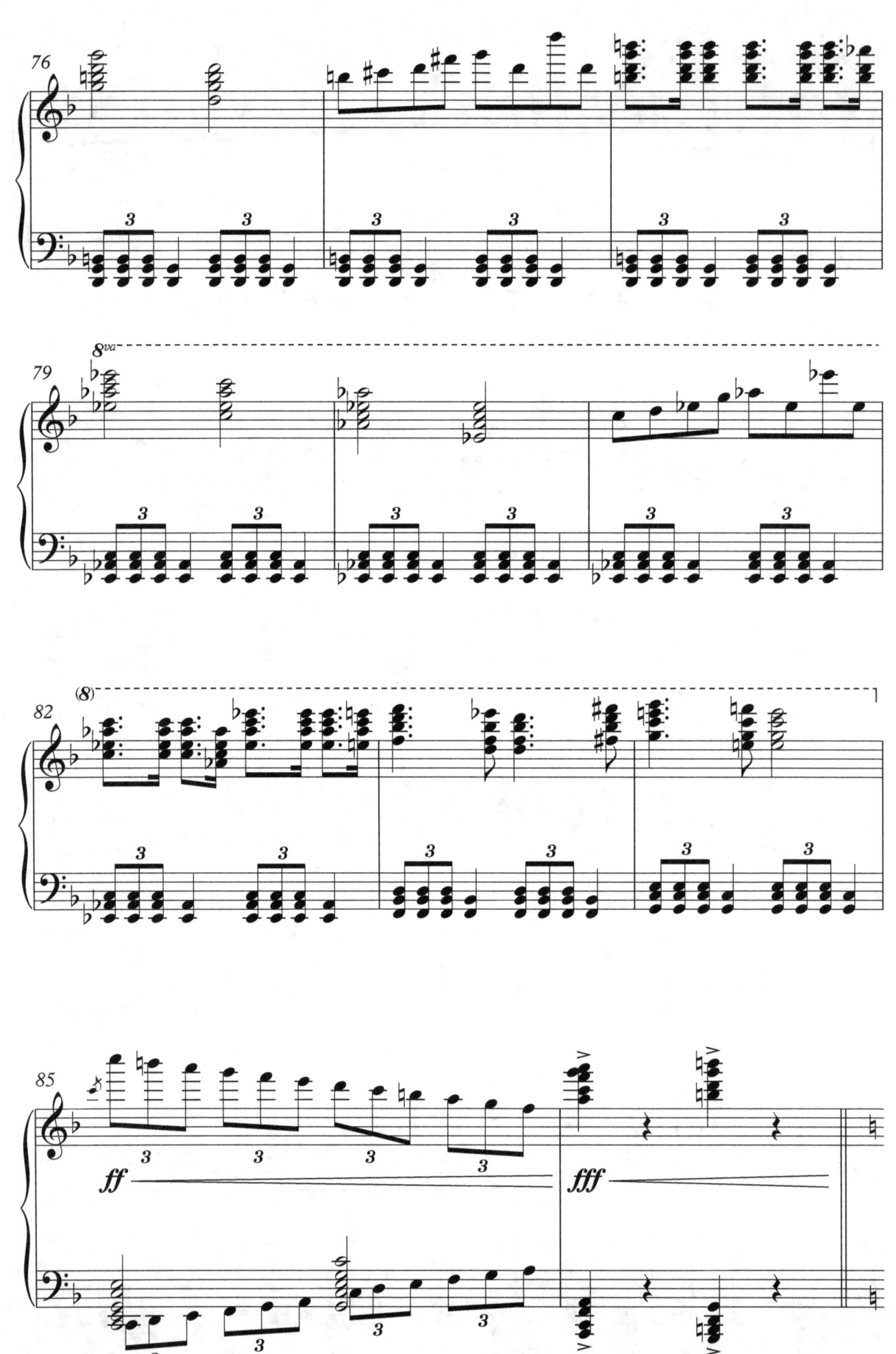

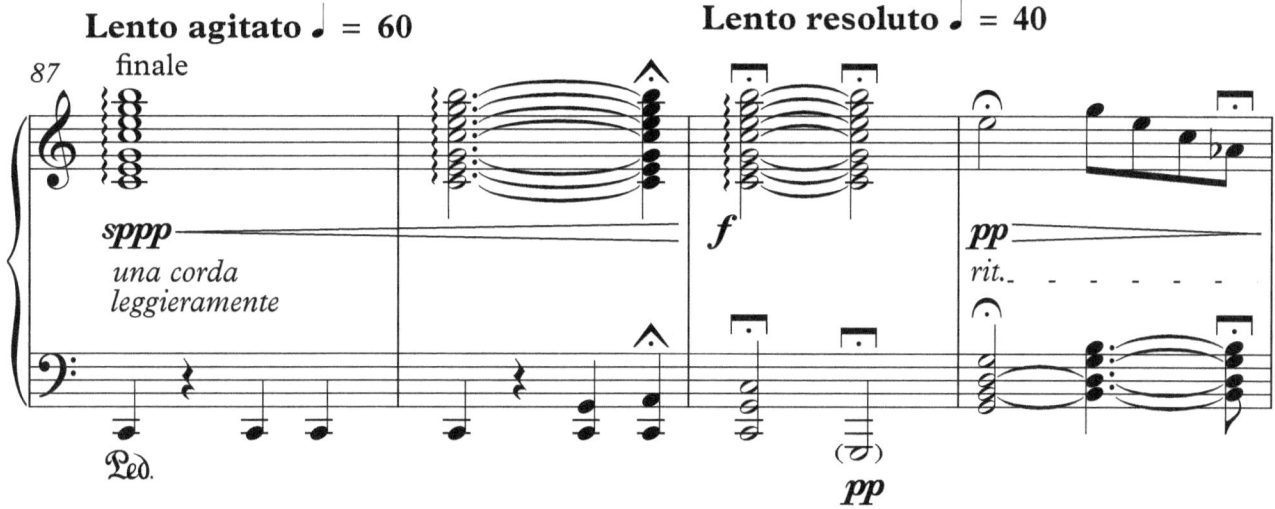

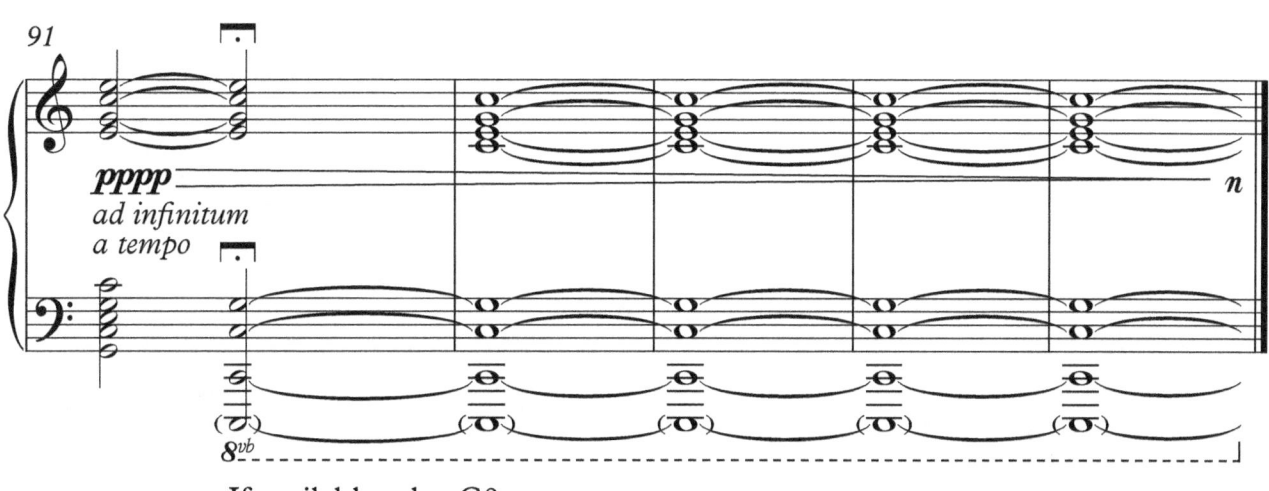

If available, play C0